The Bicycle

200 YEARS ON TWO WHEELS

mirrorpix

The
History
Press

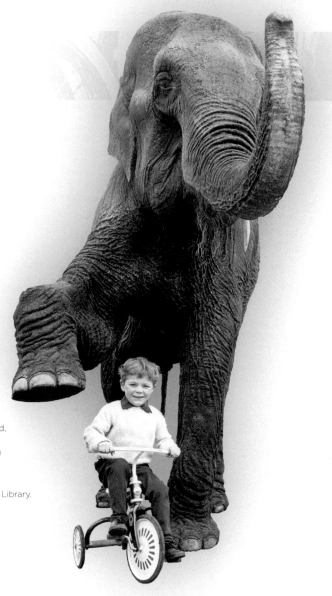

First published 2017

The History Press
The Mill, Brimscombe Port
Stroud, Gloucestershire, GL5 2QG
www.thehistorypress.co.uk

British Library Cataloguing in Publication Data.
A catalogue record for this book is available from the British Library.

ISBN 978 0 7509 8005 0

Typesetting and origination by The History Press
Printed in Turkey

Foreword

In 1817, in the southwestern city of Mannheim, Germany, an inventor named Karl Drais created the first machine to employ the principles of propulsion we recognise in a modern bicycle, first riding this exciting new machine on 12 June of that year. His inelegantly named Laufmaschine, or the hobby horse or dandy horse as it was called in England, literally means 'running machine' and requires the rider to perch on the two-wheeled contraption and use his feet to push along the ground, all the while steering by means of the front wheel and handlebar arrangement.

Later on the French, very sensibly, added cranks and pedals to the mix and what became commonly known as the velocipede was born. Michaux and Company began mass producing this revolutionary new vehicle in the 1860s and it was a great success, though not without its problems. The main issue was the shockingly uncomfortable nature of the ride, which led to it being given the disparaging moniker, 'Boneshaker'. The penny-farthing's large front wheel was an attempted response to this, but soon alternative 'safety bicycles' were developed, enabling the rider's feet to be near the ground, and keeping their feet away from the front wheel.

The advent of the bicycle opened up a whole new world for both men and women. The thrill of personal transportation fuelled the bike boom of the 1890s and once an appetite for cycling had been firmly established, there was no turning back. Indeed, the humble bicycle played no small part in sustaining societies through world wars, peacetime strikes, demonstrations, women's suffrage ... all manner of historical events were aided by the ability to jump on a bicycle and pedal off independently and under one's own steam.

Today the bicycle enjoys a privileged position as one of the most globally successful means of personal transport, as well as a beacon of sportsmanship. Cycling sporting heroes have become icons, whether Olympians or Paralympians, or stars of Tours and road-races. The impressive Mirrorpix photographic archive, home to one of the world's largest photographic libraries, with over 100 million images and more than a century of news coverage, is the perfect medium to present the changing fashions of the bicycle as it reaches its 200th anniversary. From dustmen to postmen, from children to soldiers, from amateur Polo clubs to Paralympians, these beautiful and evocative images reveal the power and impact of the bicycle upon society across the changing years.

Put your feet up and enjoy the ride!

The Bicycle

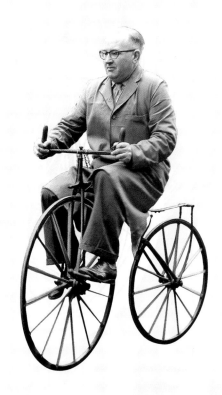

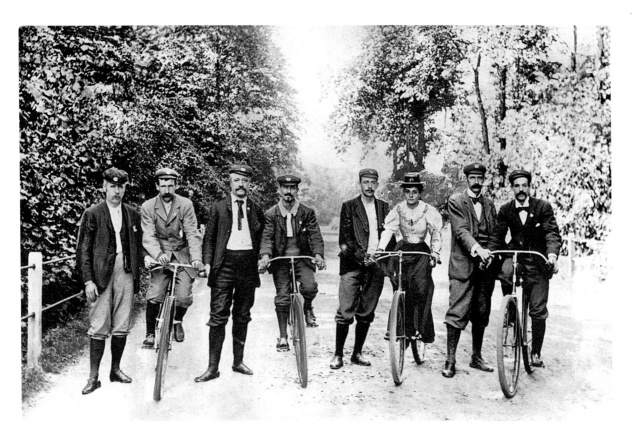

A rare picture of the pioneer members of the Novocastrian Cycling Club in 1891. This scene includes the club's only lady member.

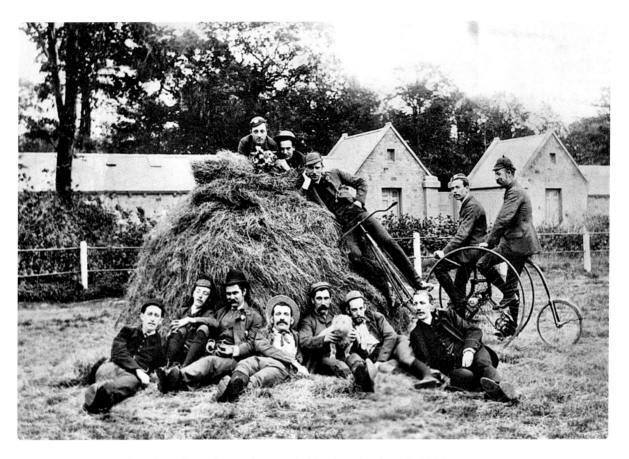

Tyneside cyclists take a breather after a day out in Northumberland in 1892.

The Bicycle

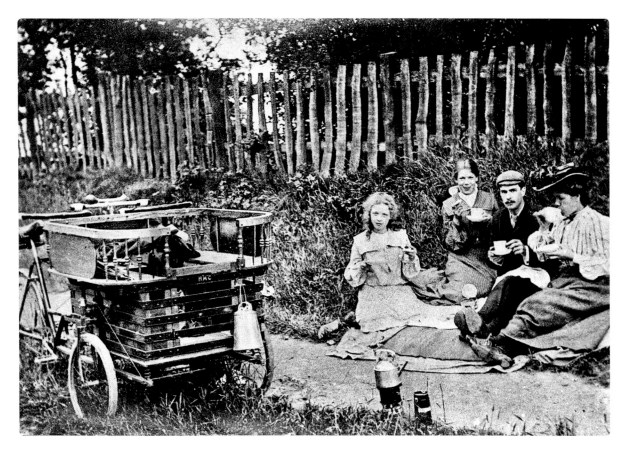

Family picnic in Birmingham *c.* 1900 featuring a Herald Motor Company (HMC) cycle.

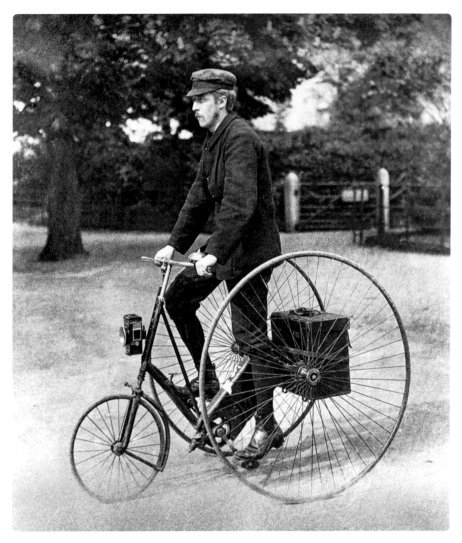

A gentleman on his
bike in the early part of
the twentieth century.

THE
Bicycle

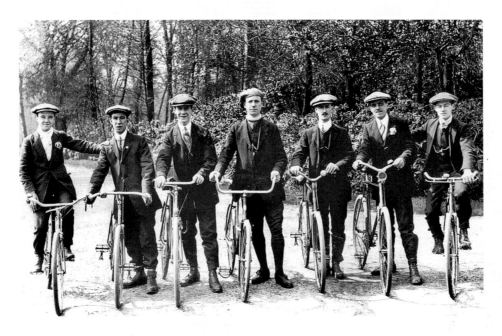

Jesmond Dene Cycle Club in 1912.

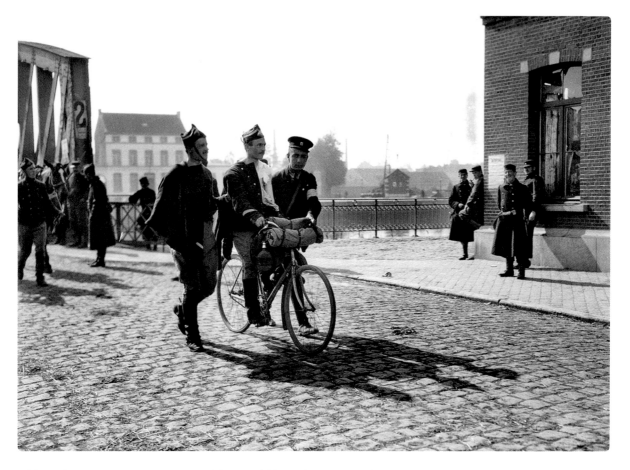

Although wounded this Belgian soldier could bicycle with a little assistance from his comrades, following the Battle of Auderghem, 26 September 1914.

THE Bicycle

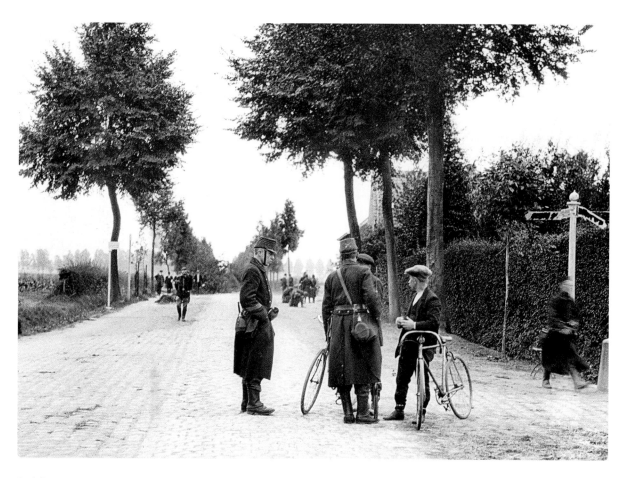

Soldiers seen here checking papers. No one was allowed to proceed in Belgium without a passport and documents on which is the holder's portrait. As can be seen in the picture the Belgian authorities have obliterated all the names on signposts in an effort to slow and confuse the German advance. (*Daily Mirror*, p. 4, 19 August 1914)

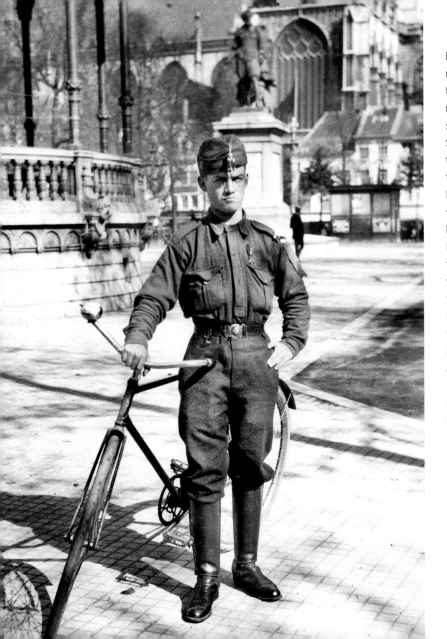

Belgian Boy Scouts carried messages deemed too private to trust to telegrams or ordinary messengers during the early stages of the First World War. Some were sent to France to gather the harvest whilst the men went off to the war. Belgian Boy Scouts were issued with pistols, as their work brought them close to the Front Line. One Boy Scout became famous at the beginning of the war following the capture of two German spies dressed as priests near Liege. After this the boy, Joseph Louis Leyssen, seen in the photograph, was allowed to help on the Front Line, and more than once rode with important messages right through the German lines. He is seen here after being decorated following his fifth engagement with the enemy, in September 1914.

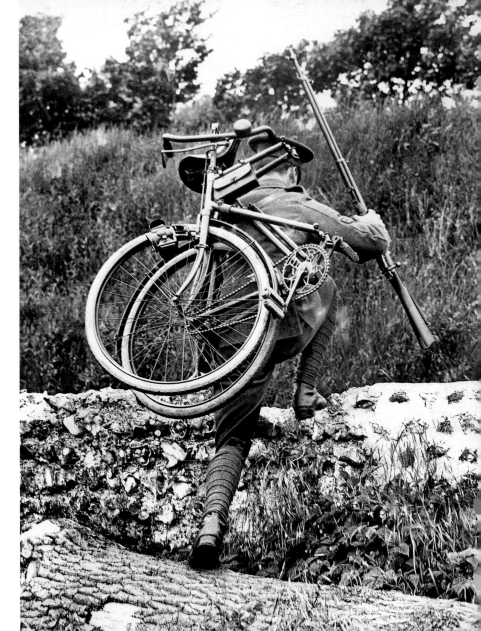

This is the new British Army Scout, in June 1915, known as the Divisional Cycle Corps, equipped with folding machines so that they could make a pursuit over any obstruction that may bar their way. It was considered one of the most useful units of the army.

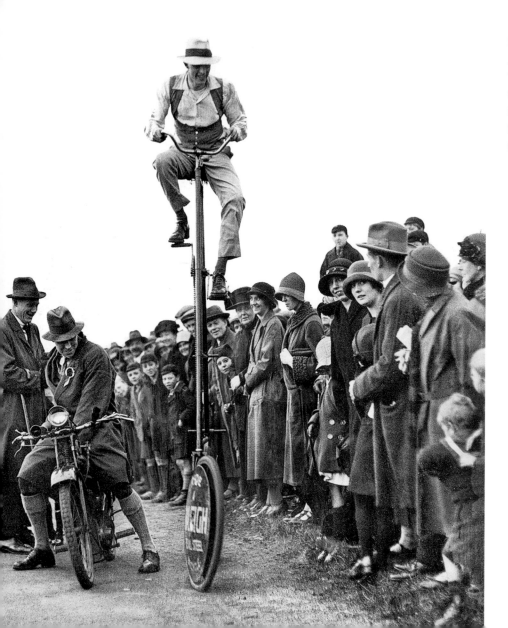

Doncaster Infirmary
Appeal, October
1925. A student on a
tall unicycle attempts
to clear the course
for the start of
the races.

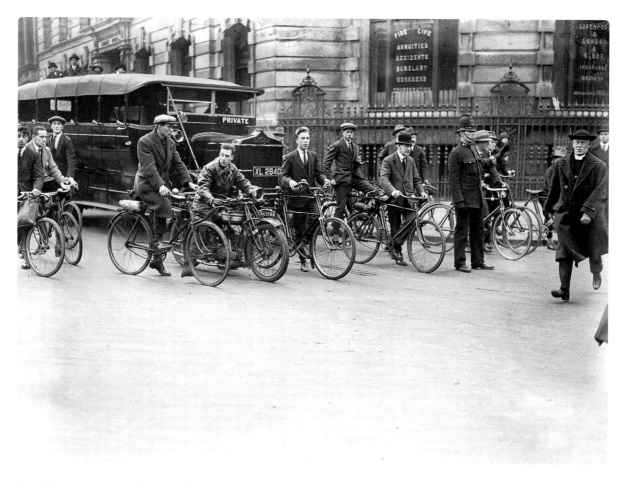

Cyclists at a London bank during the general strike of 1926.

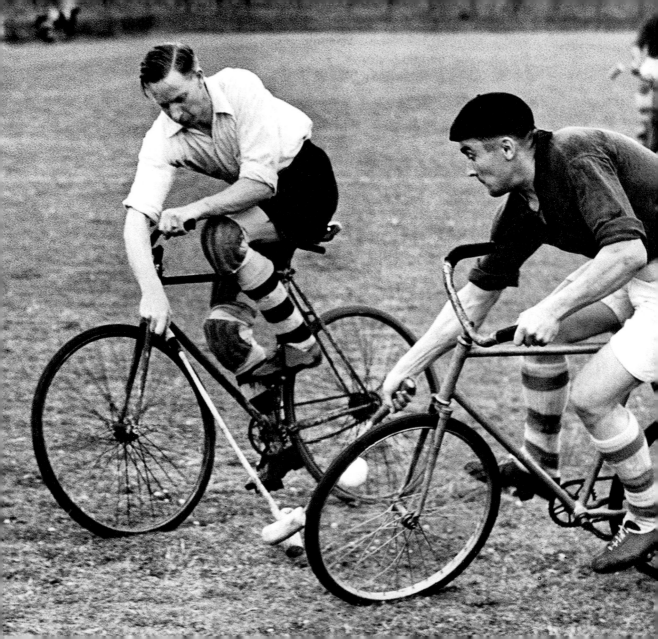

A street entertainer at Tower Hill, London, balancing a bicycle using his mouth watched by a crowd of spectators, c. 1935.

Three fellows playing cycle polo, which was invented in County Wicklow, Ireland, in 1891 by retired cyclist Richard J. Mecredy. The sport is similar to traditional polo except that bicycles are used instead of horses. (13 June 1937)

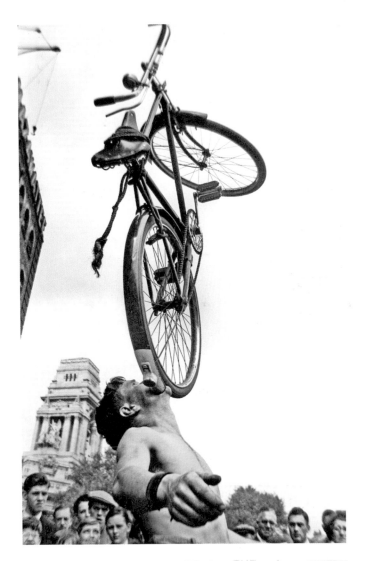

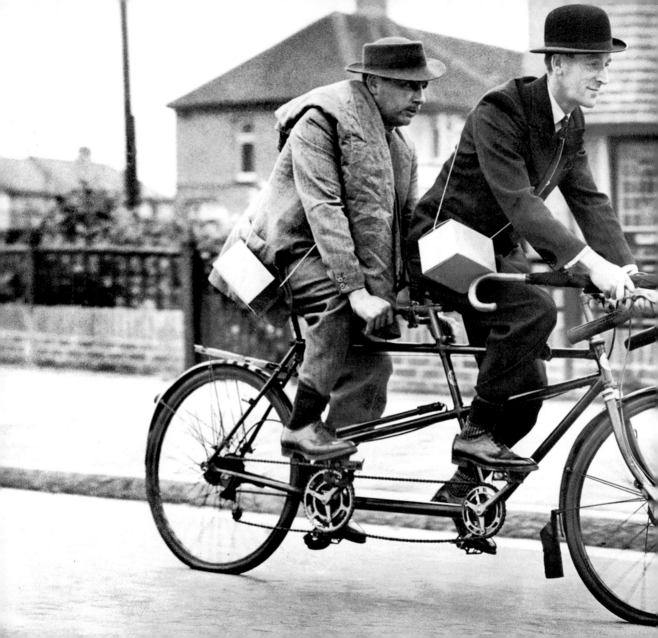

Two businessmen who usually travel to town by car share a tandem cycle after the introduction of petrol rationing on 22 September 1939.

Girl Guides receive notes to be delivered to members of the Home Guard, 22 October 1940.

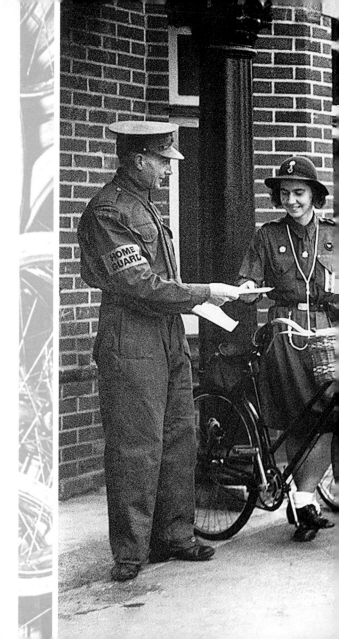

THE
Bicycle

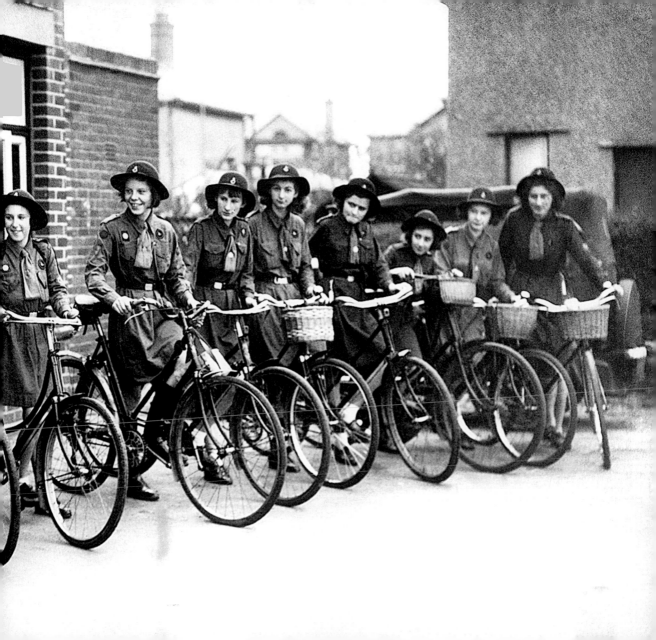

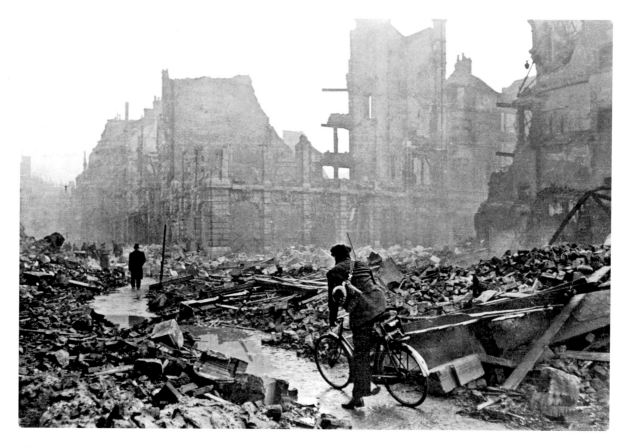

Blitz: taken from the German word *Blitzkrieg* ('lightning war'), this was the British name for the Luftwaffe's sustained night attacks against their cities from August 1940 to mid 1941. A man on a bicycle makes his way through war-ravaged London.

The Bicycle

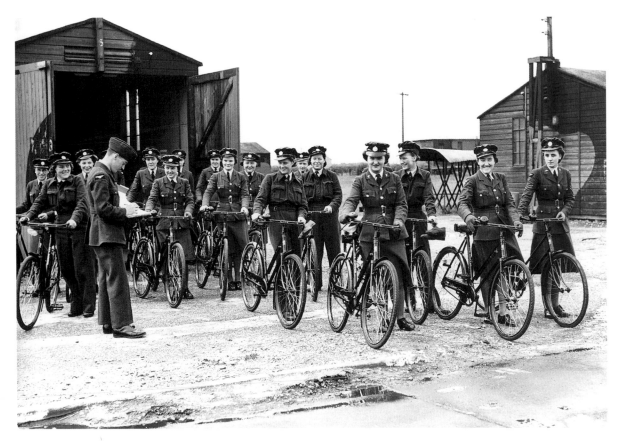

Women's Auxiliary Air Force (WAAF) on an RAF base wheel out their bicycles at the end of their shifts, in 1942. They were issued with bikes to save fuel.

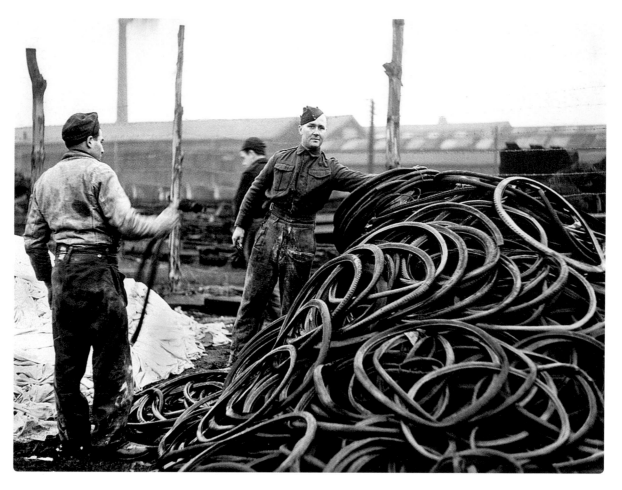

The war on waste is seen here at a Western Command Salvage Depot. Men from the yard inspect salvaged bicycle tyres piling up, January 1943.

The Bicycle

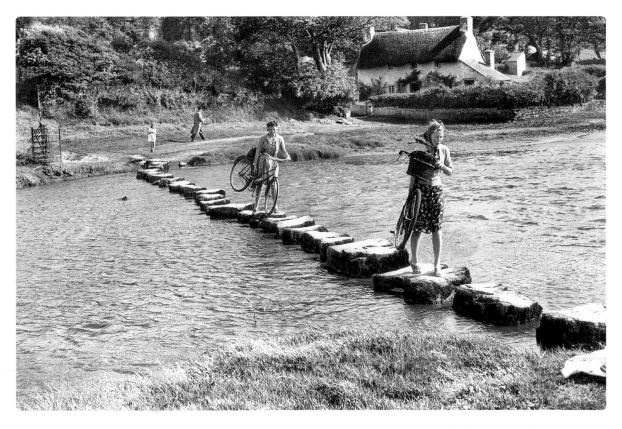

A couple of young women use stepping stones to cross the River Ewenny, which rises to the north-east of Bridgend town, South Wales, flows past the village of Pencoed and enters the River Ogmore estuary just below Ogmore Castle, July 1943.

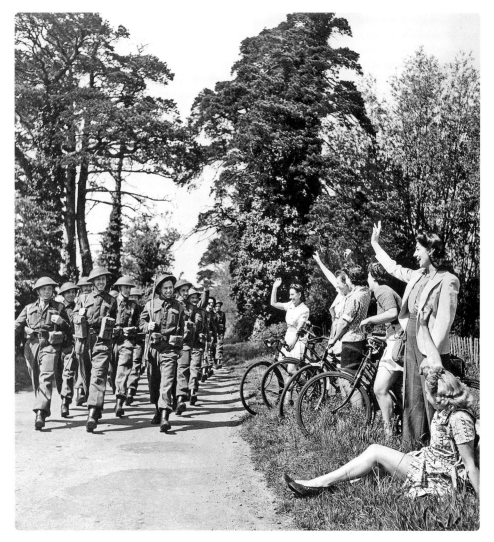

Home Guard volunteers are cheered by local residents sitting on the side of the road as they run through a training exercise in Weybridge, Surrey, during the Second World War, 24 May 1943.

THE
Bicycle

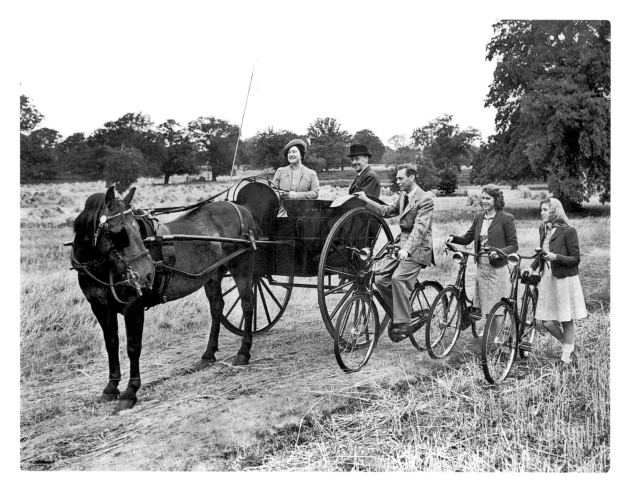

Royal tour and inspection of crops at Sandringham, Norfolk. King George and family travel in a pony trap to avoid the use of petrol, 13 August 1943.

LAC Stanley Mallett RAF gives a French girl a lift on a borrowed bike, wearing uniform and tin helmet, rifle slung over the shoulder, in August 1944.

THE
Bicycle

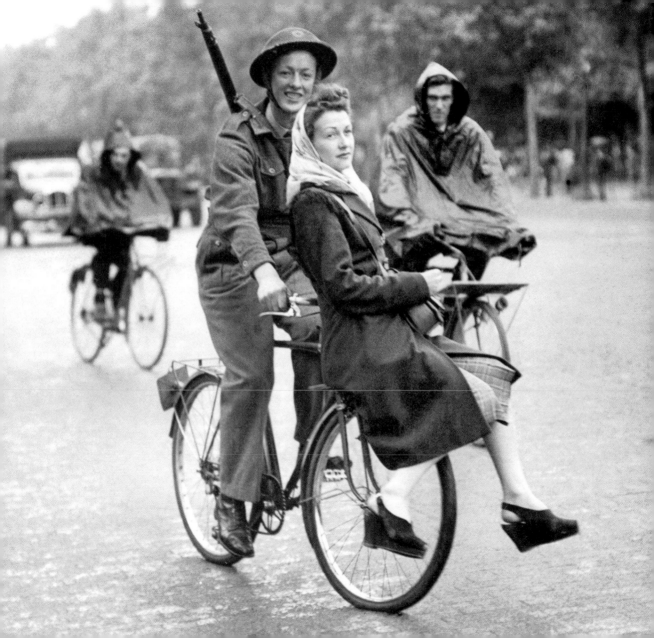

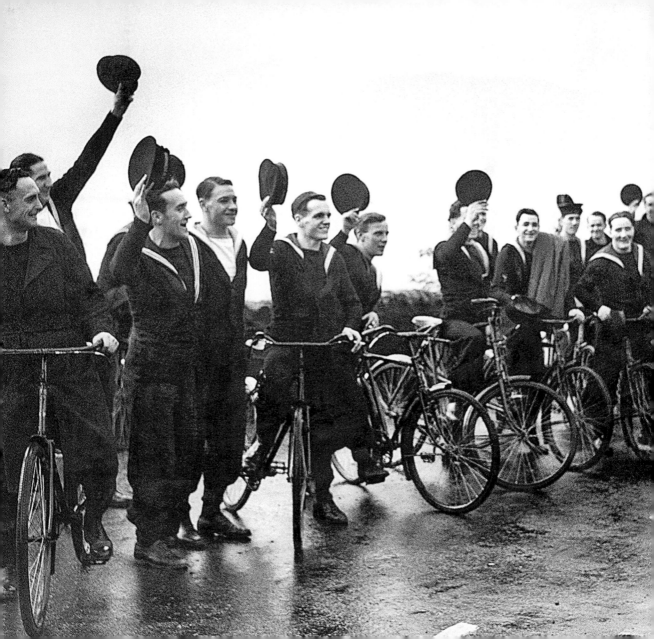

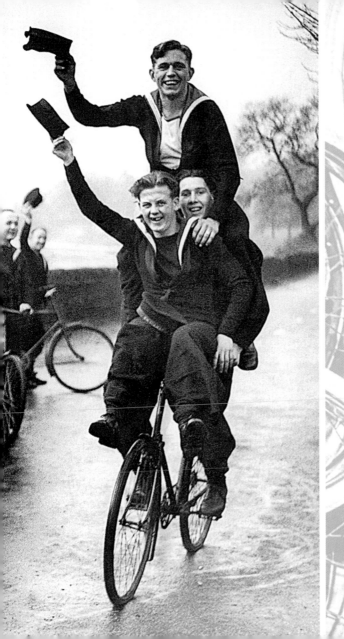

Sailors from a navy submarine seen here enjoying some shore leave with bicycles provided by Raleigh. (February 1944)

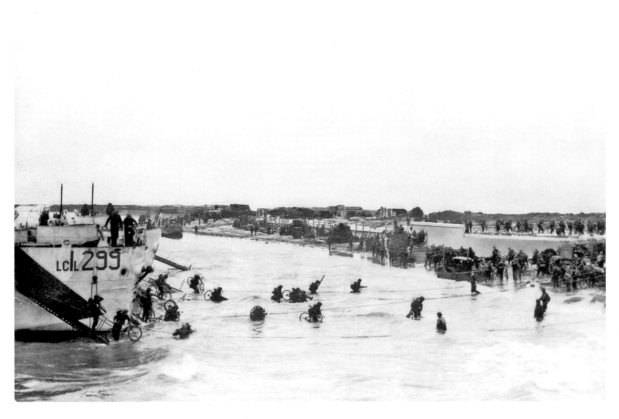

Troops of the Canadian 9th Infantry Brigade part of 3rd Division carrying their bicycles ashore from landing craft LCL 299 in the Nan White Sector of Juno Beach shortly after midday on D-Day, 6 June 1944.

The Bicycle

A young girl rides a bicycle with her pet dog in the basket on the front handlebars, *c*. 1945.

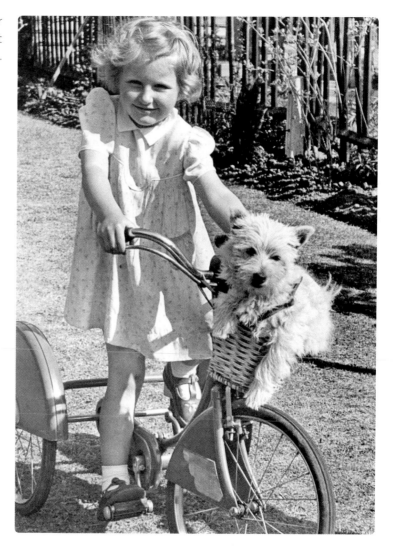

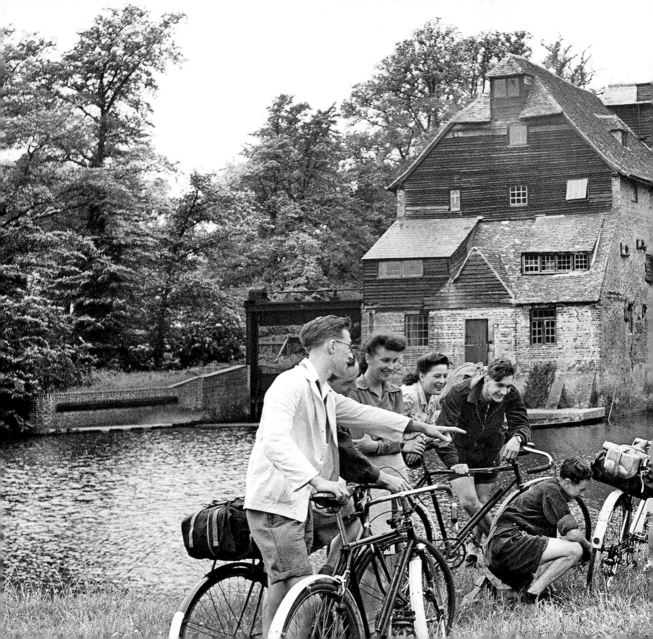

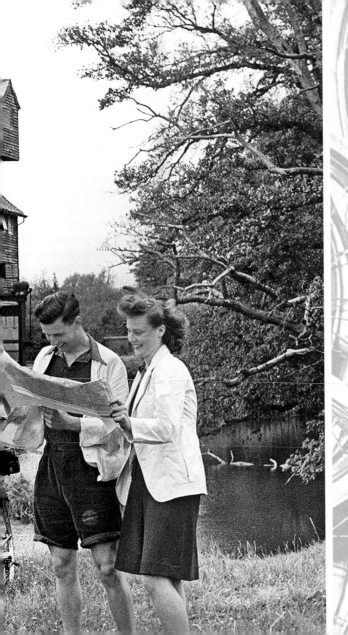

Members of the Youth Hostel
Association at Houghton Mill in
Houghton, Cambridgeshire, c. 1945.

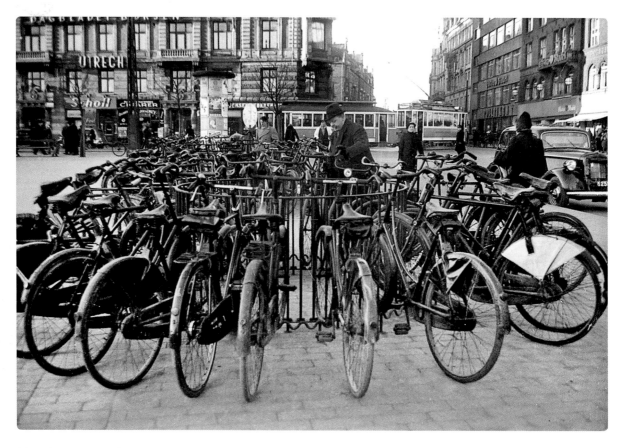

Bicycles in Copenhagen, Denmark, December 1946.

THE Bicycle

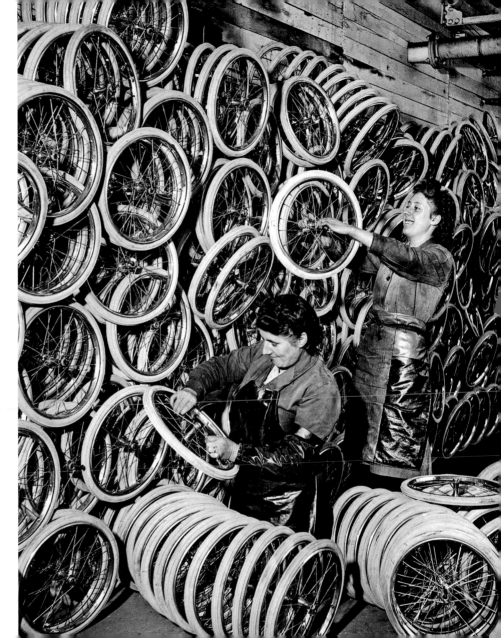

100,000 wheels of all sizes being produced at Morden, 13 December 1947.

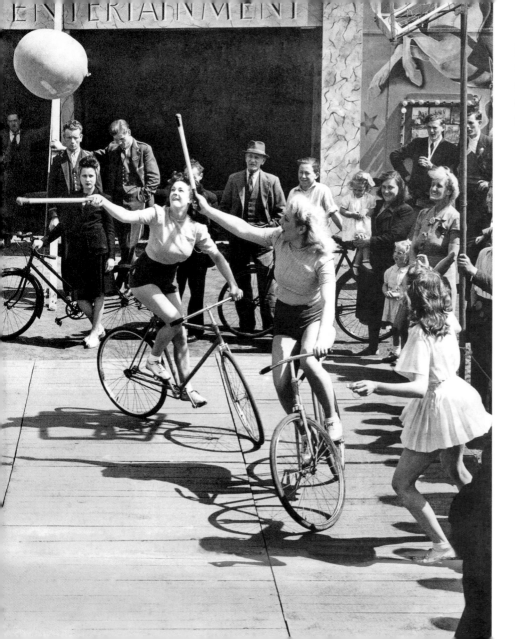

Part of a cycling netball team, the girls practise each day for an hour without stopping.

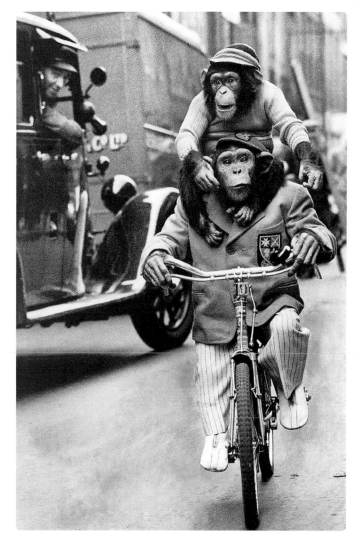

Marquis the chimpanzee riding a bicycle and carrying 2-year-old Baron on his shoulders, while out on their morning exercise in the West End of London, 22 September 1948. Later, the troupe of chimpanzees was to become known as 'Marquis and Family'. In 1960, the Marquis Chimps — Enoch, Susie, Baron and Hans — were signed to appear in a trio of television commercials for Brooke Bond Foods, makers of Red Rose Tea. The commercials featured the chimps in parodies of a Wild West shootout, a golf match and the most popular, a wild nightclub with a swinging chimp band singing the praises of Red Rose Tea.

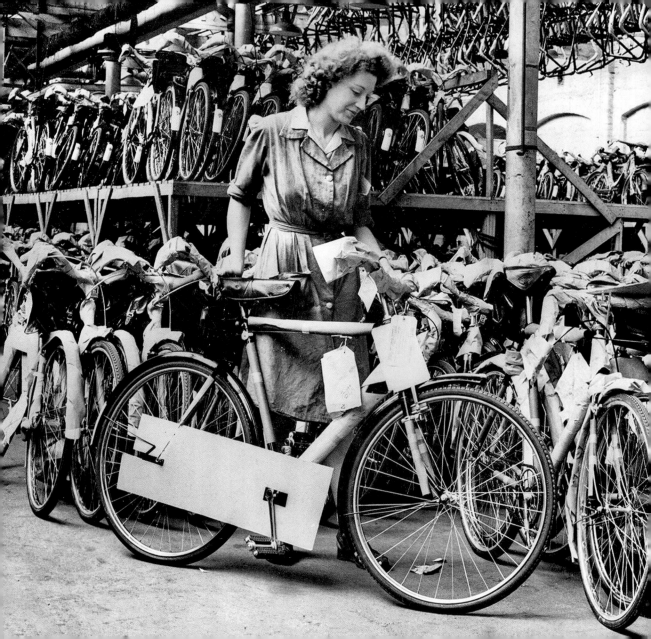

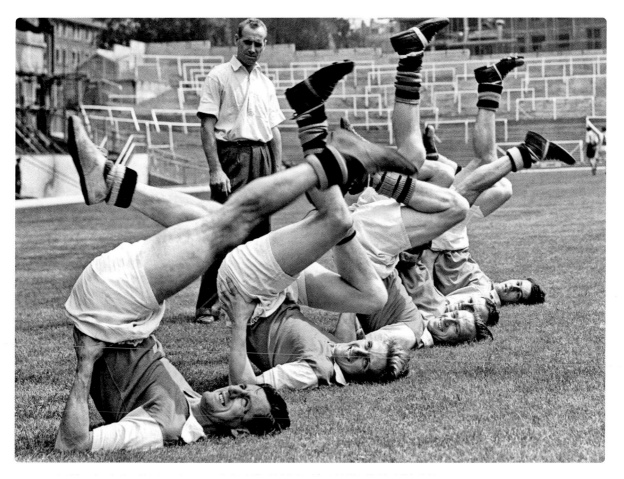

Arsenal players Swindin, Goring, Smith, Horsfield and Holton pictured during a training session on the pitch at Highbury, August 1950.

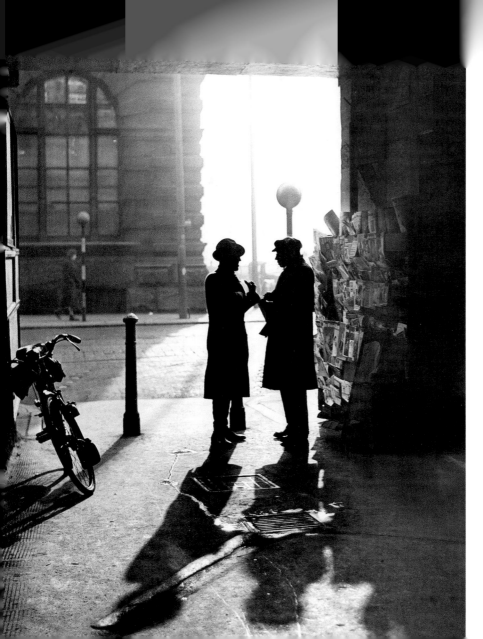

newspaper seller under
the covered entrance
to Leather Lane, off
Dale Street, Liverpool,
17 January 1950.

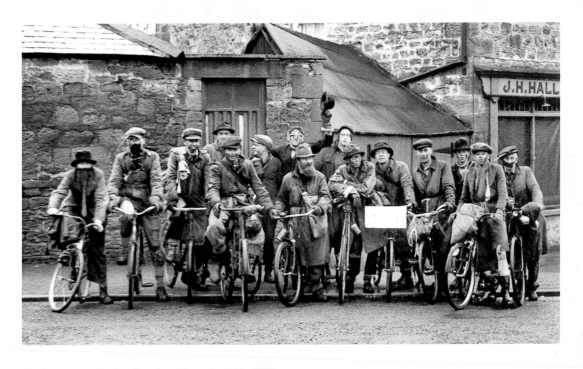

Cyclists on a 'Hobo Run' at Ponteland in 1951.

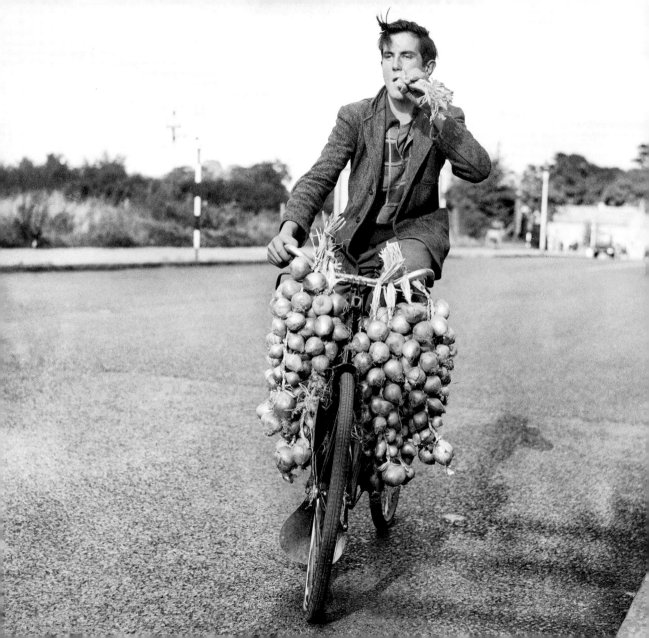

Mr Gallou Pierre seen here after just arriving in Bristol with his onions, which he takes round on his bicycle. Mr Pierre, from Plouenan, Finistere, France, liked onions himself and also a stick of English celery, which he is here pictured eating, 22 September 1952.

Robert the dog sits on the butcher's bicycle dressed for the job, June 1951.

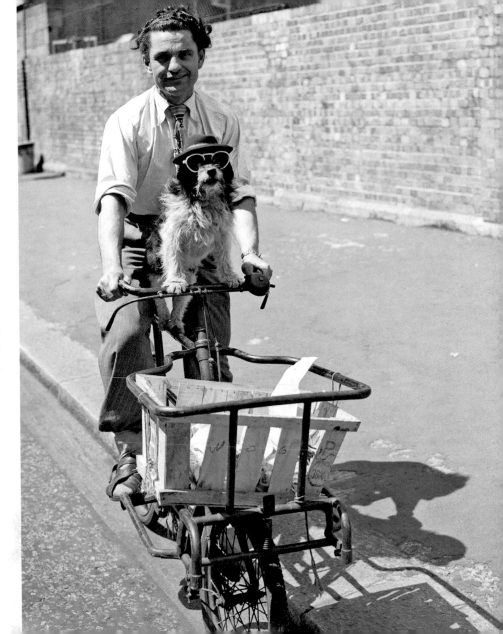

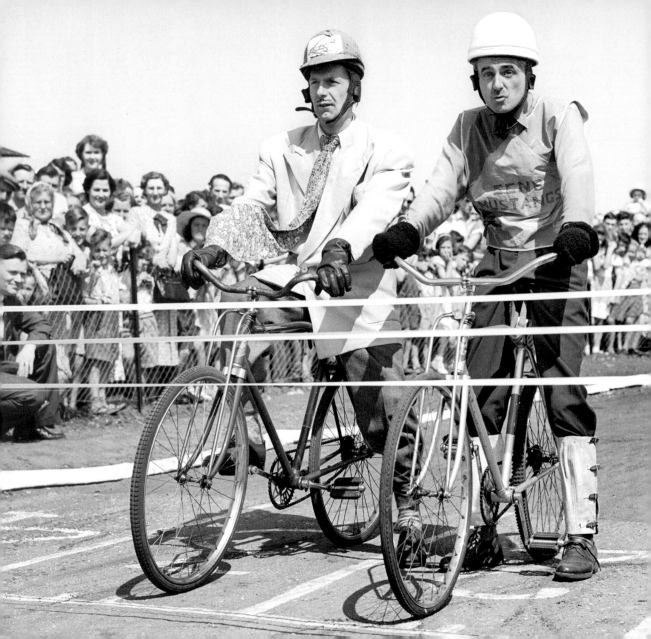

Arthur English, left, lines up against Tom Phillips on the Skid Kids Cycle Track in London, 18 May 1952. (*Daily Mirror*, p. 11, 19 May 1952)

Lorchen the parrot takes the dove Heinz for a ride — on a bicycle on a tightrope. They are just one part of an act from Germany billed as 'Carola and his Cockatoos', December 1952.

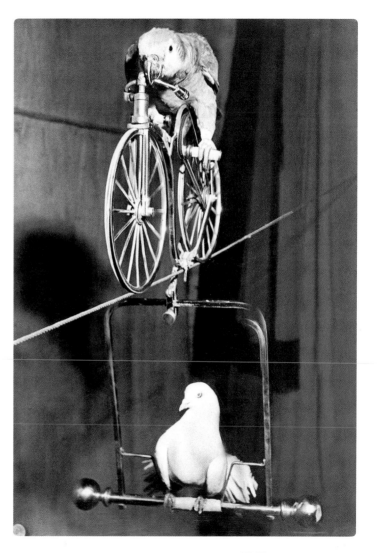

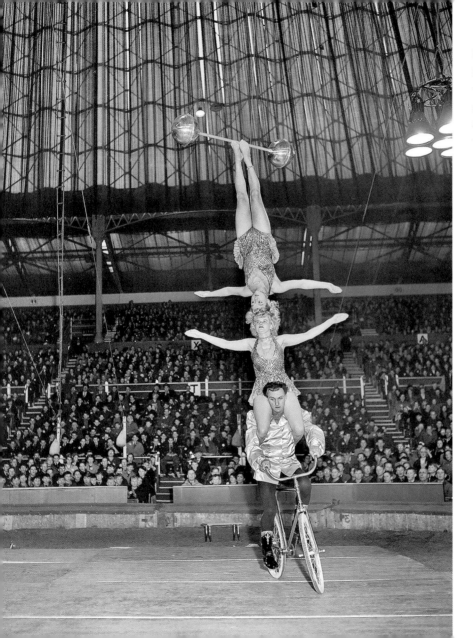

Bertram Mills Circus acts, December 1952. Two women balance on the shoulders of man riding a bicycle in the ring at the circus.

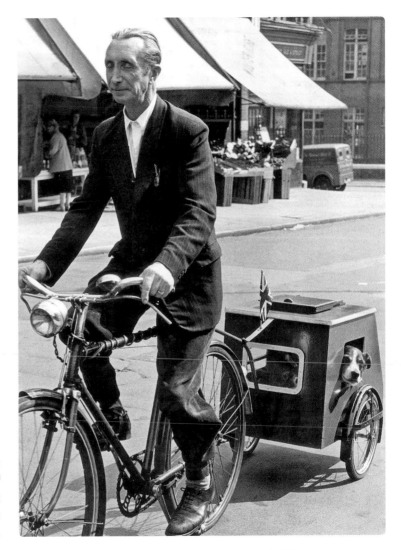

Here the inventor of the 'dog caravan', Mr C. Tumbridge of Kensal Rise tows Prince, a Jack Russell dog, along behind his pushbike.

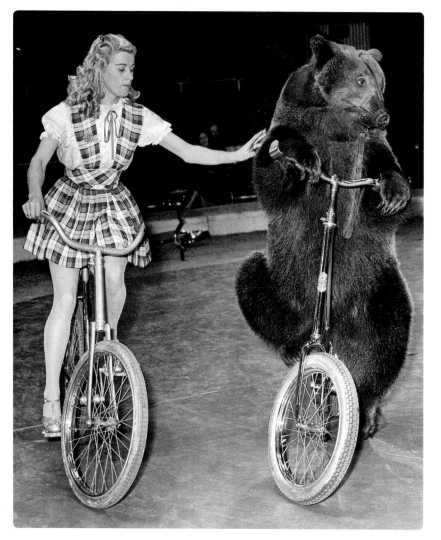

Dress Rehearsal of Jack Hylton's circus at Earls Court, London, which opened on 23 December. One of the highlights of the show was Louisa Galwas and her performing bears. Louisa is seen here riding a bicycle alongside one of the bears, 'Maika', in December 1953.

Members of the Warwick Lions, Hackney Comets and Arsenal Aces cycle speedway clubs battled on the Warwick Lions track, in Hackney, September 1953, for The Battle of Britain Trophy awarded to the individual champion. This event is held annually and is sponsored by the Hackney branch of the Royal Air Forces Association (RAFA), whose funds benefit from a collection made on the ground.

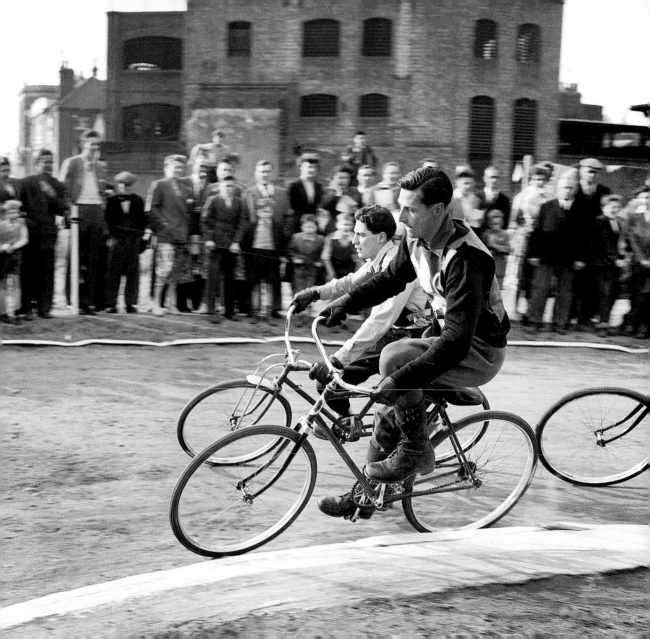

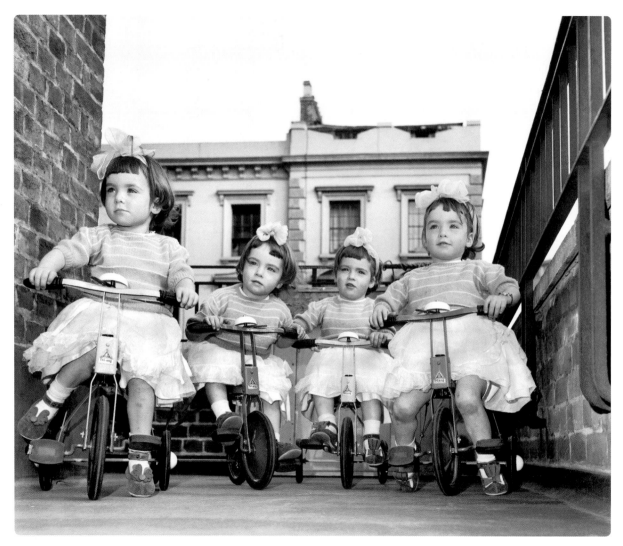

THE
Bicycle

The Cole quadruplets seen here on their new bikes, which were given as birthday presents, September 1953.

Stout Banner Forbett seen here setting the record for sitting still on a bicycle, May 1953.

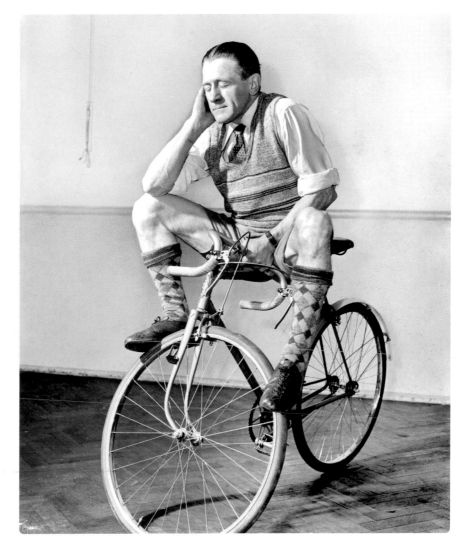

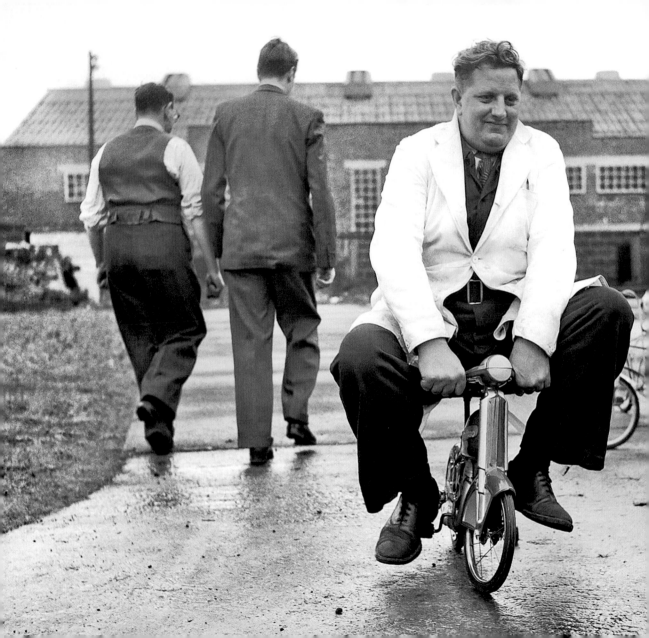

Man testing children's toy bicycles and rocking horses, December 1953.

An early form of tricycle. With the addition of a big wheel it could be made to carry another person, March 1954.

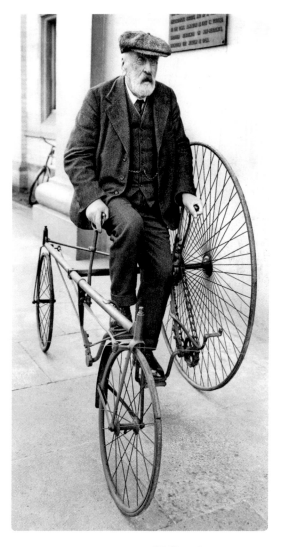

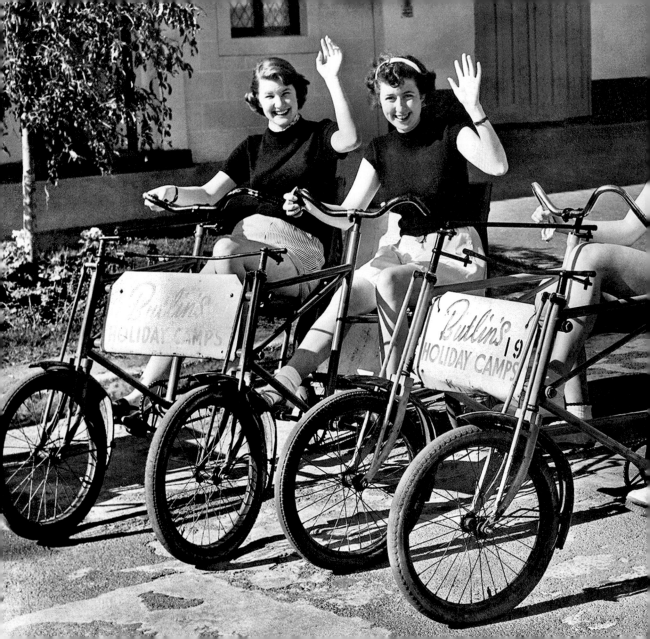

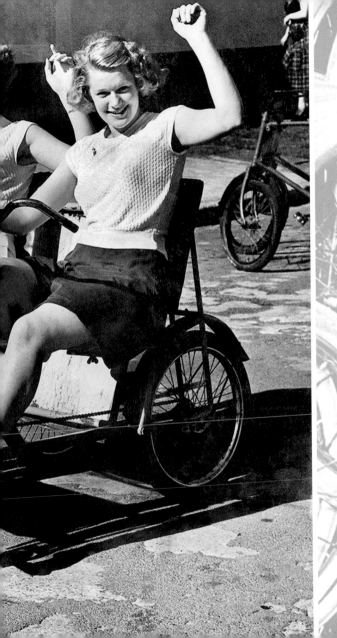

Butlins (left to right): Peggy Brown and Joan Smith of South Wales and Margaret Jones and Marry Etherington of Preston have fun on social cycles, July 1954.

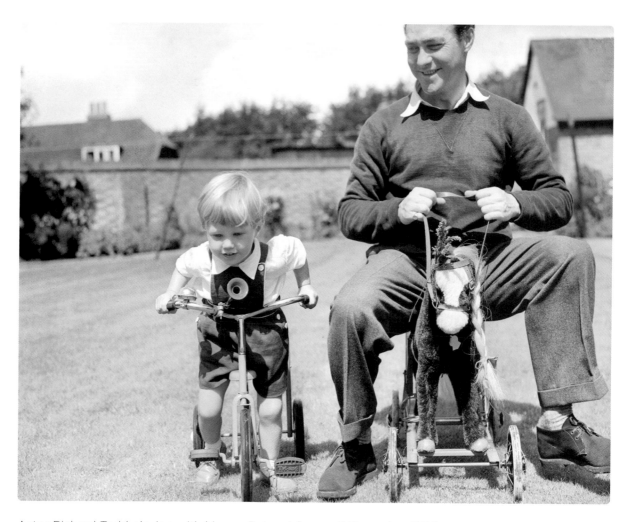

Actor Richard Todd playing with his son Peter at home, 5 November 1954.

The Bicycle

Trick cyclist on stilts leans against a Glasgow tram in 1954 to advertise a circus.

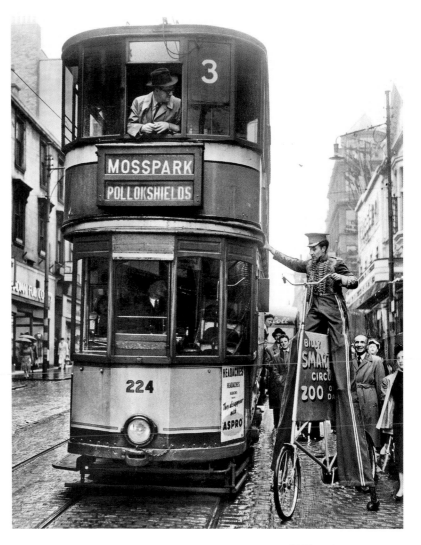

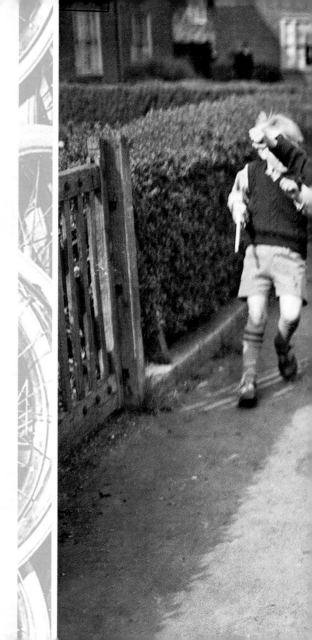

Boys playing on a council estate as one of their mothers looks on, London 1955.

THE
Bicycle

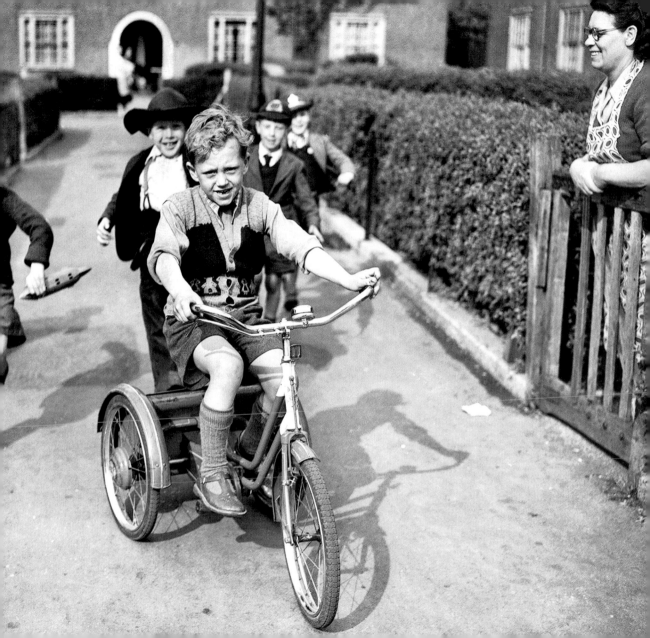

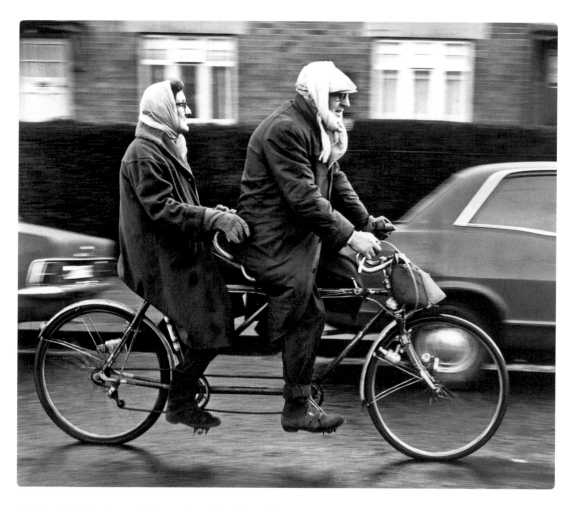

Mr Charlie Hemley on his tandem, October 1954.

THE Bicycle

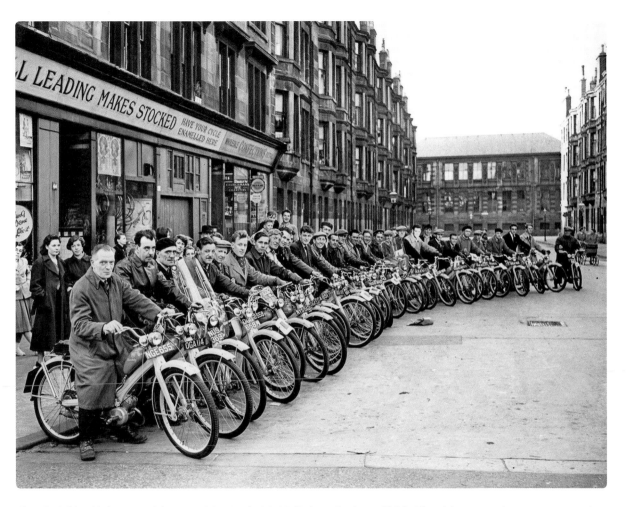

The Quickly Club assembles outside Andy McNeil shop in June 1956. The thirty members are preparing their first motorcycle run from Langlands Road, Glasgow, to Houston.

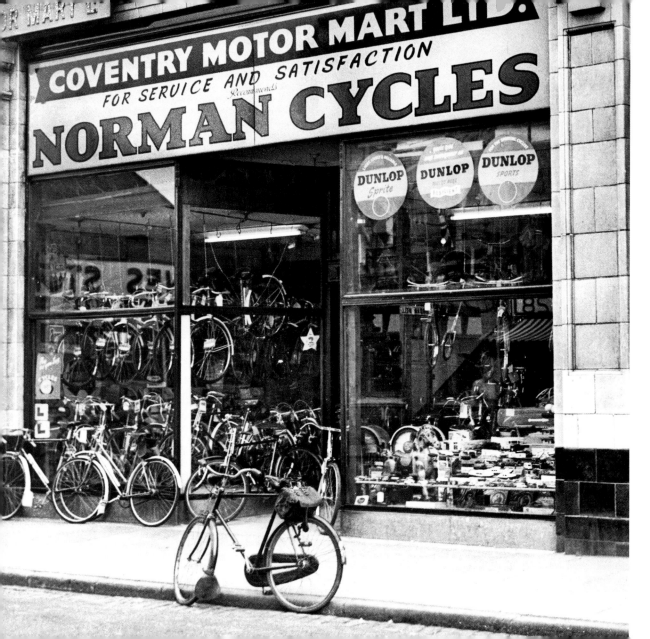

Coventry Motor Mart bicycle shop on White Friars Street, Coventry, c. 1957.

Miss Cycling 1898 (left) alongside Miss Cycling 1959, November 1958. Together these two vintage misses (appropriately dressed for their parts) went cycling along the Thames Embankment. Miss 1898 was riding an old-fashioned sit-up-and-beg model, whilst Miss 1958 rode a Scoo-ped, the latest idea in pushbikes. Enclosed in a fibreglass body, the Scoo-ped is made by the Elswick-Hopper Cycle and Motor Company.

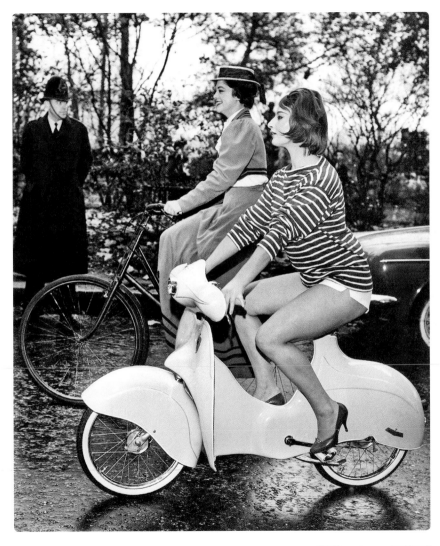

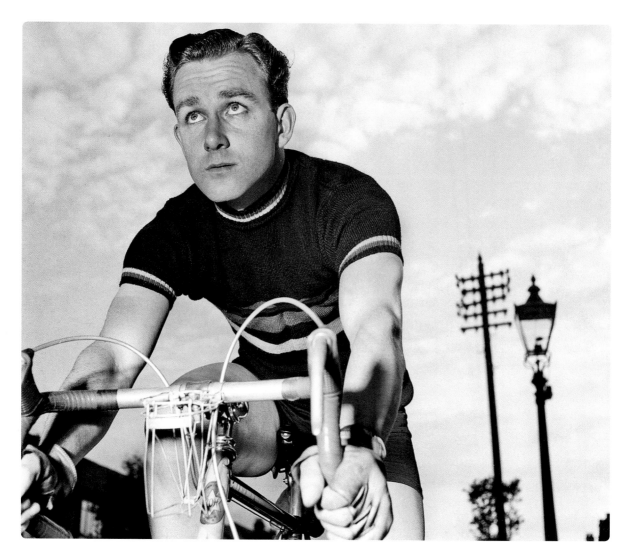

THE
Bicycle

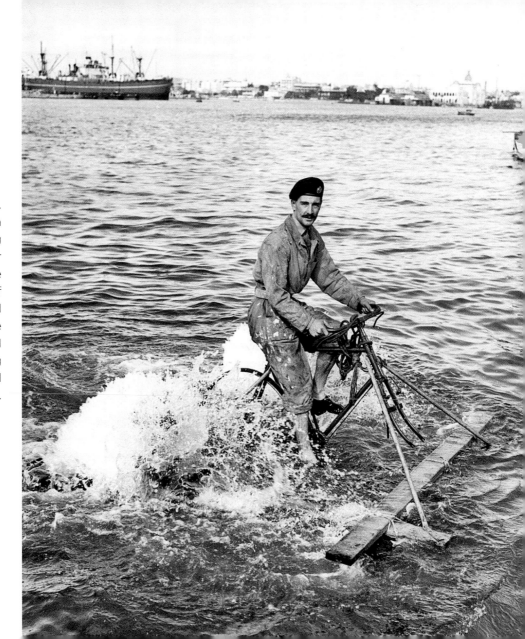

Olympic cyclist Ron Stretton seen here training for the 1956 games, May 1953.

Suez Crisis, 1956. Lieutenant John Young crossing Port Said harbour on a pedal bike raft – product of the improvisational skills of the sappers of 1001 Docks Operating Company Royal Engineers.

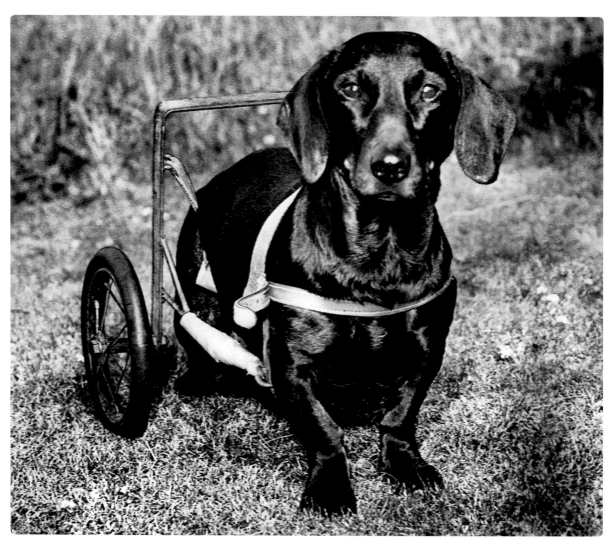

THE
Bicycle

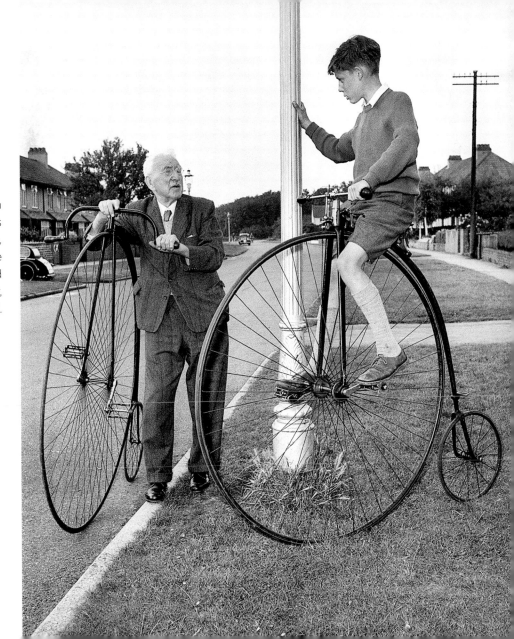

Moss the dachshund suffering a slipped disc is seen here in a canine wheelchair, June 1960.

Charles Westley seen here with part of his old bike collection, which includes the penny-farthing and the boneshaker, Bristol 1961.

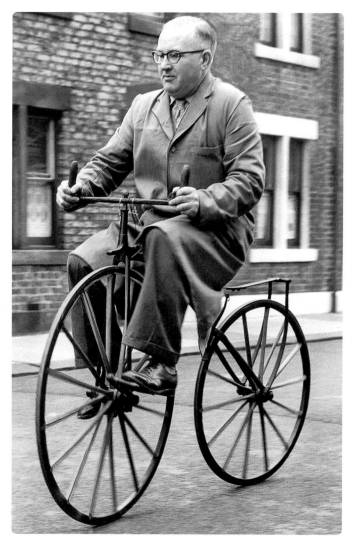

Mr Ernest Sander on his 1860 boneshaker in 1960.

Girls of Crediton High School in Devon on a three-day cycling tour of Devon during the Whitsun bank holiday. The girls, aged between 14 and 17, spend nights in youth hostels along the way, 21 May 1961.

THE Bicycle

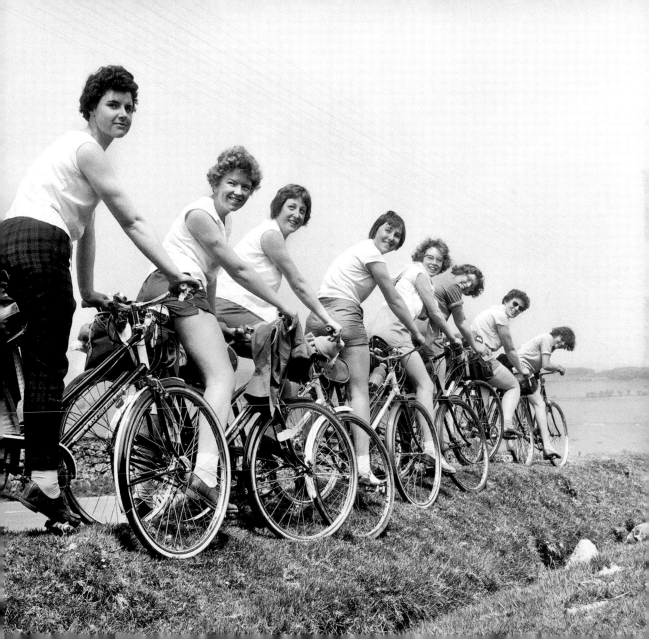

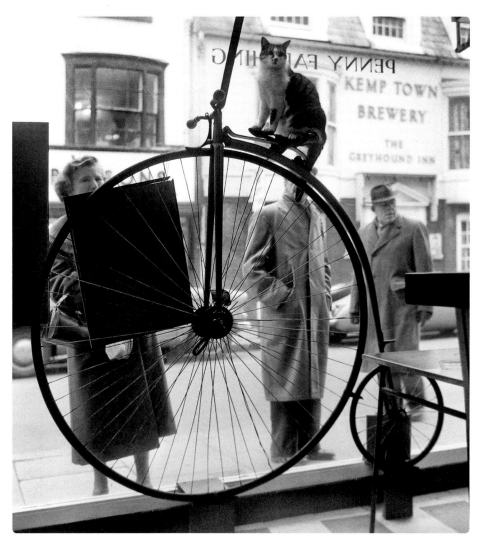

People stand and stare in the window of the Penny Farthing Coffee Bar in Brighton and watch Susie the cat sitting on the saddle of the huge penny-farthing in the window, February 1961.

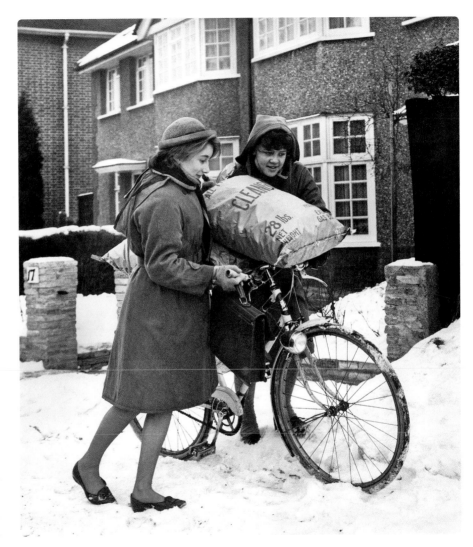

Broxbourne Grammar schoolgirls, Christine Wallace (left) and Jone Hay, walk home from school with two sacks of fuel as well as their homework, January 1963.

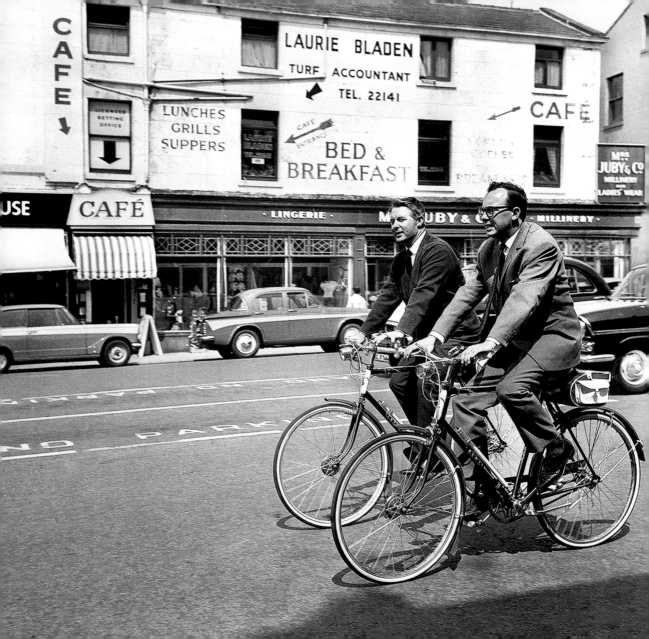

Morecambe and Wise in June 1963 cycling around Blackpool.

Winston Churchill at Royal Academy annual dinner, May 1963.

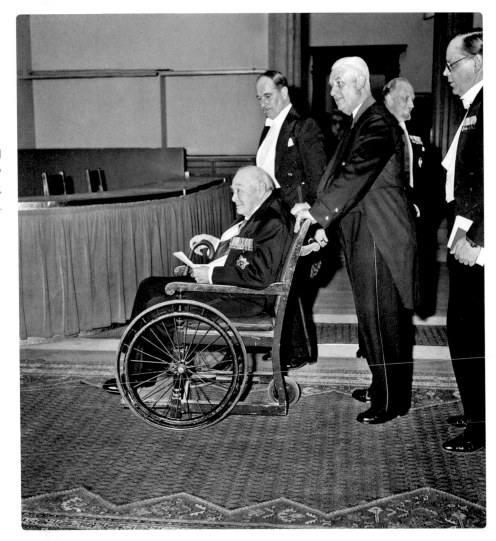

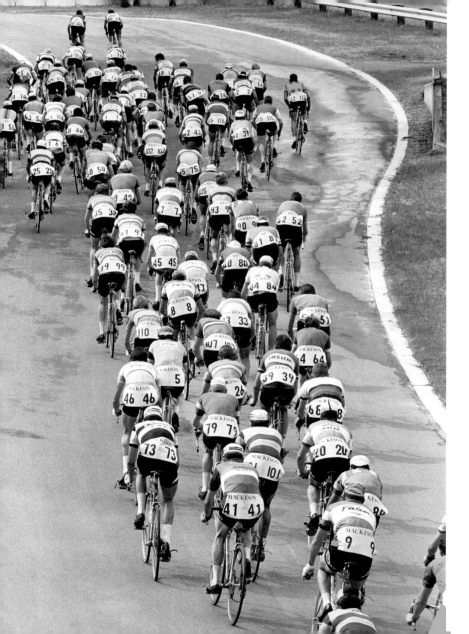

Mackeson premier at the
Crystal Palace racetrack,
9 August 1964.

Tour of Britain cycle race,
Blackpool, Lancashire,
7 June 1964.

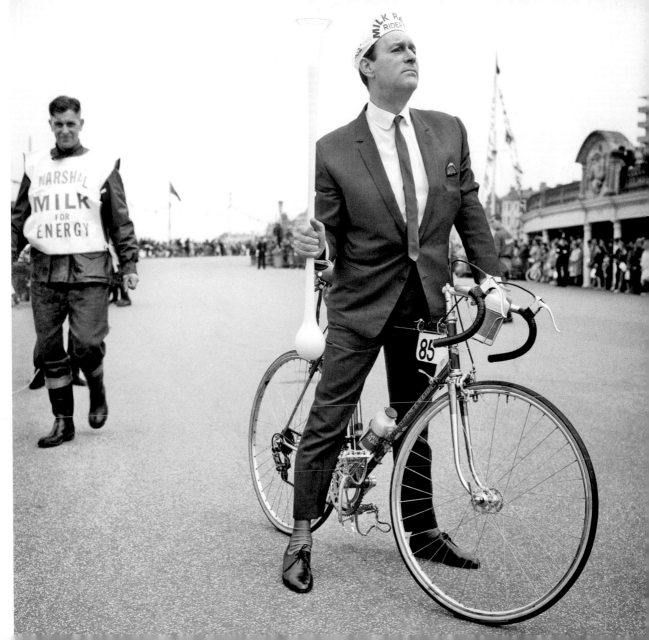

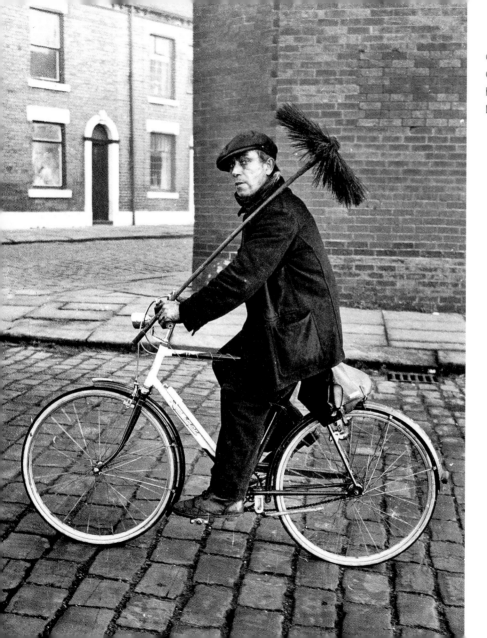

Chimney sweep Fred Gibson riding a bike on his round in Chadderton, Lancashire, in 1965.

Clifford Davis of Leeds Road, Wakefield, tries out his flying machine made from bits of old pedal cycles. Maxwell Hemingway, 6, looks on in wonder at Mr Davis' flying machine, in West Yorkshire, 25 June 1965.

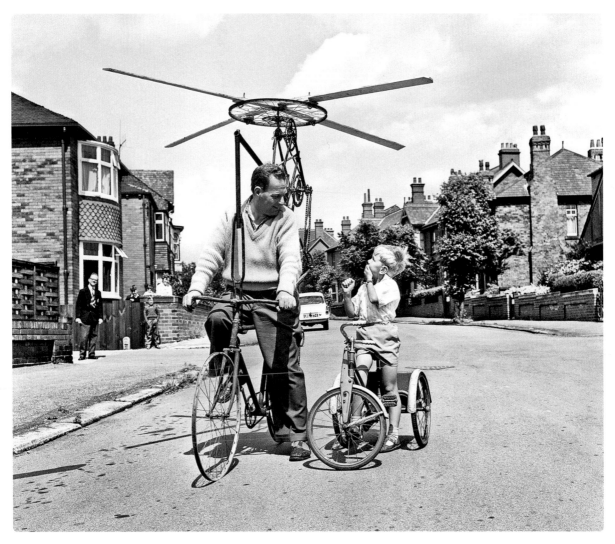

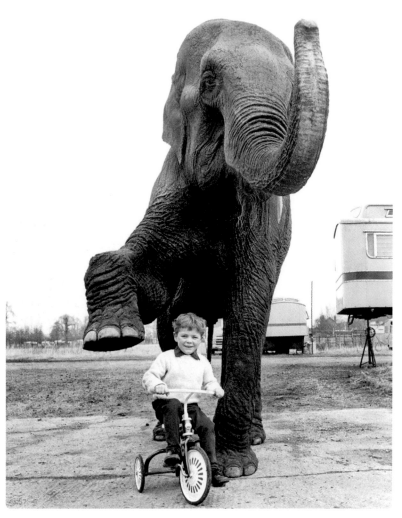

A child with an elephant, February 1965.

Linda Carruthers, Valerie Harrison, Gillian Carruthers and Allison Carruthers trying out the comfort of a Victorian pram on 28 October 1965.

THE
Bicycle

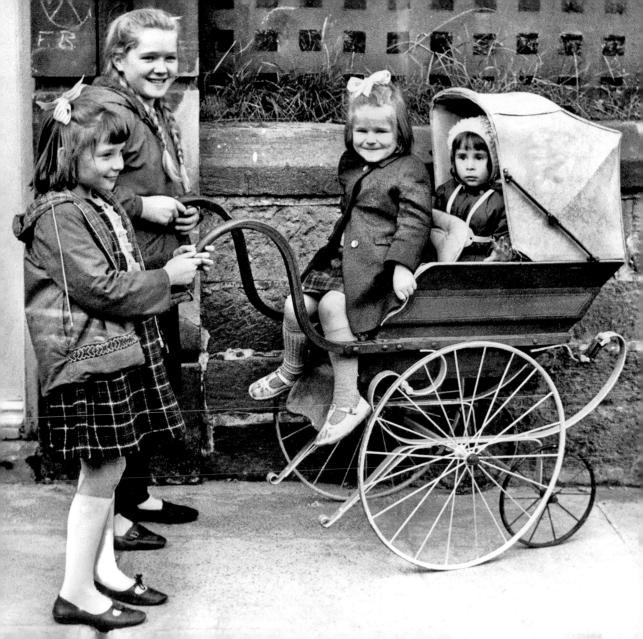

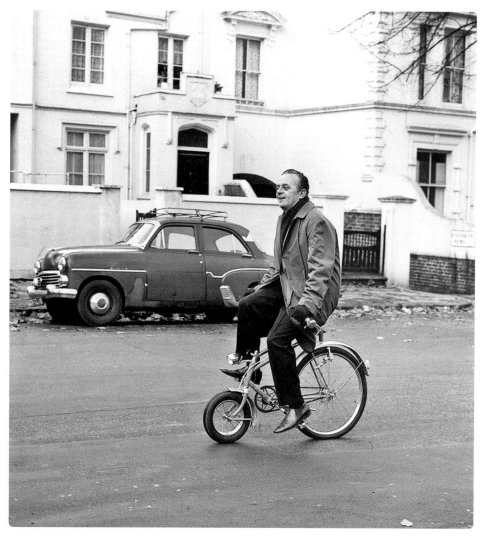

World-famous
harmonica player
Larry Adler
on his way to
a concert at
Camden Town on
a 'Donkey Bike'.

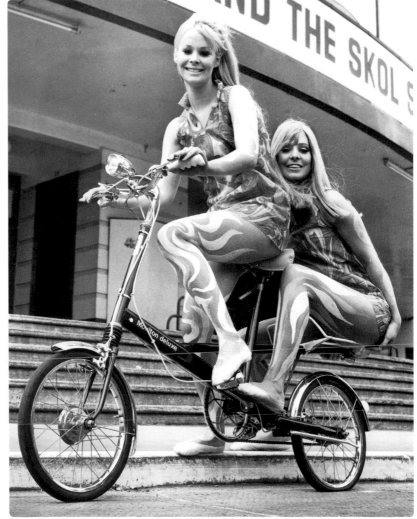

Helping to launch the Skol six-day cycle race models Sue Donoghue and Jill Bernard are seen here on the forecourt of Earls Court Exhibition Hall on 12 September 1967. They are dressed in the newest fashions designed by Falcon Stuart in his studio shop in Pimlico Road, Westminster.

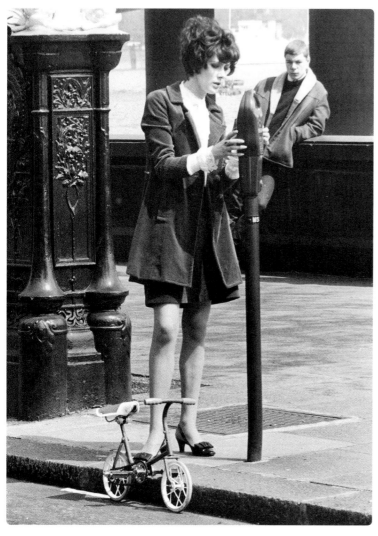

Actress Sue Lloyd puts money in a parking meter for her mini bicycle on the Embankment in London, May 1967.

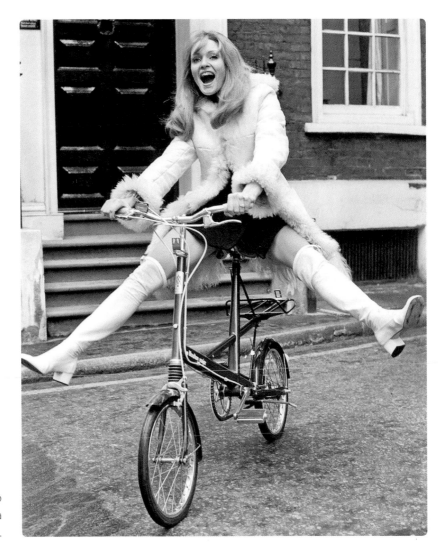

Model Blanche Webb wearing a fur jacket, riding a bicycle, November 1969.

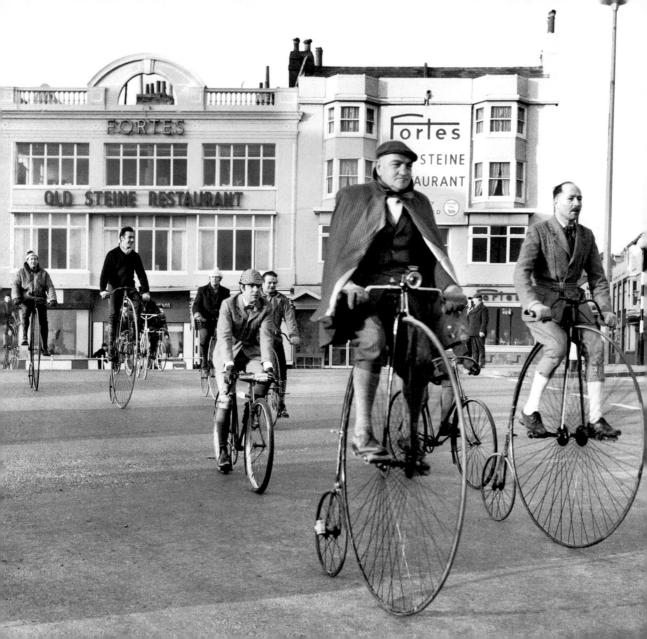

Cyclists arrive in Brighton, East Sussex, for the Brighton to London bike ride, 9 February 1969.

'I hope they've put out the fire by now,' said Alfred Hitchcock whilst at Claridges in September 1969.

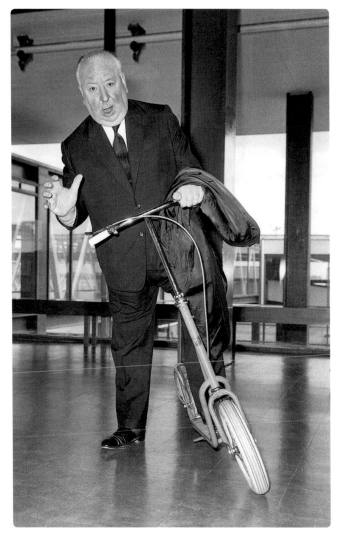

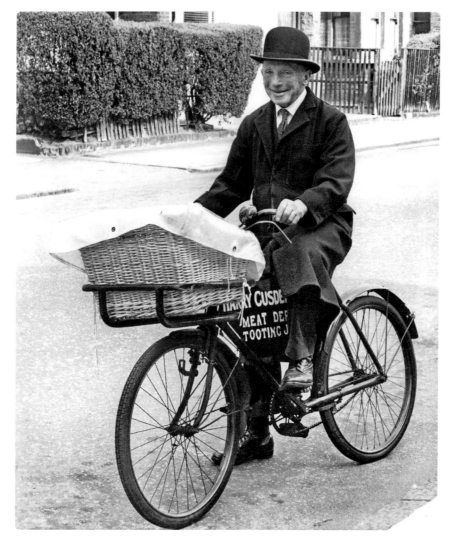

George Rees, Britain's oldest butcher's boy, riding on a pushbike in April 1968. Note the bowler hat, and the neat overcoat covering the traditional blue-and-white striped apron. The basket is full of choice joints and cutlets and plump prime sausages.

THE
Bicycle

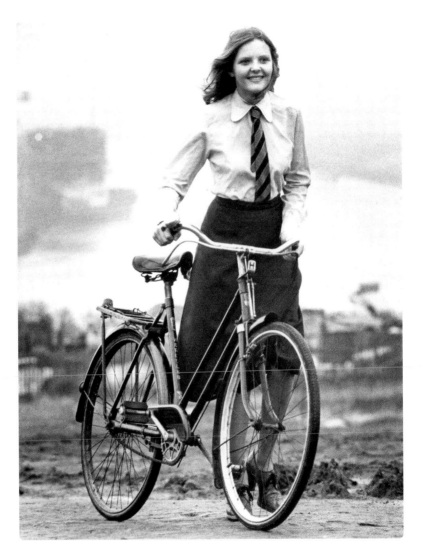

Miss Dawn Whittaker takes a break from cycling a 1935 bike on a trip around her Tyneside home in 1970.

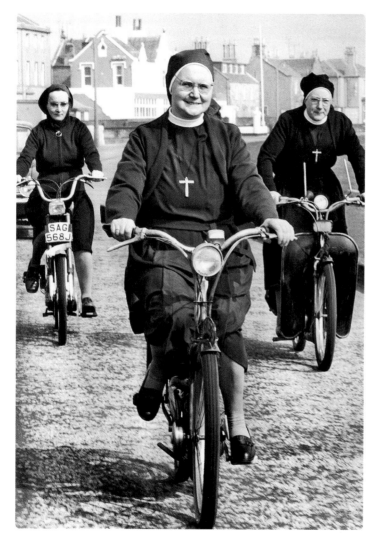

Nuns on motorbikes in Ardrossan, Scotland, 30 April 1971. Heaven's answer to the Hells Angels roars along the seaside promenade. Sisters of Misericorde – Sister Anne-Marie (left), Sister Anne and Sister Peter Patrick – travel more than 100 miles a week on their motorbikes, visiting sick and elderly people in and around Ardrossan.

Model Susan Sayer riding the iconic chopper bike, December 1971.

THE Bicycle

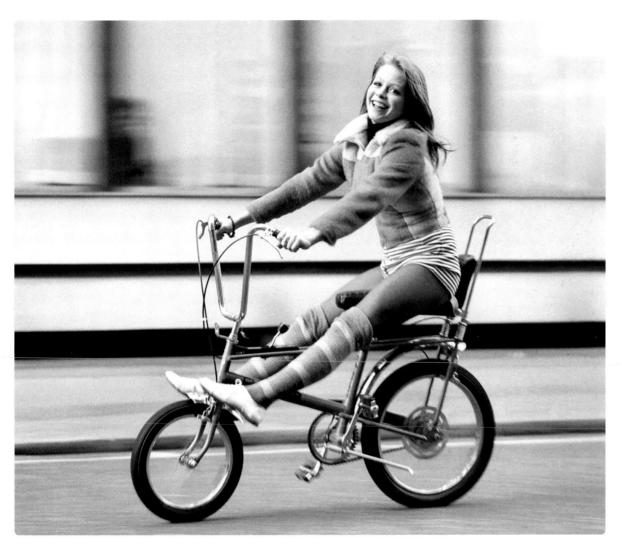

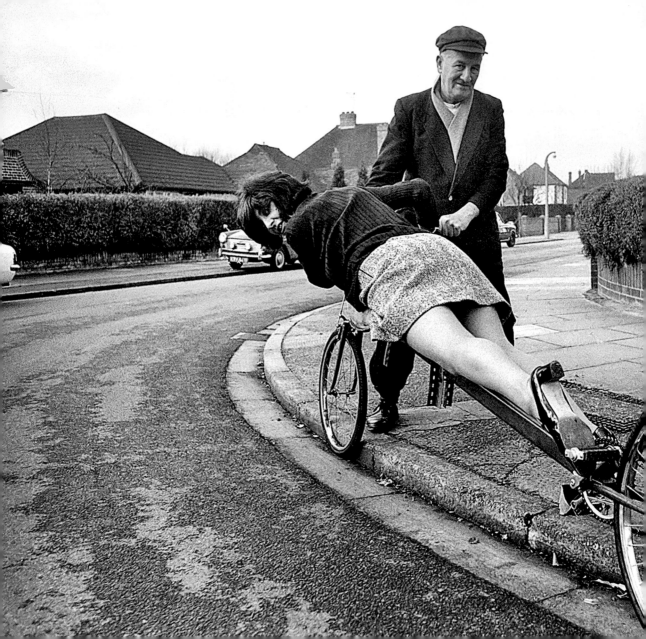

73-year-old Patrick Thomas of Laleham, Middlesex, has made himself this 9ft-long bicycle, which he rides lying on his stomach. Pat claims the bike gives him extra speed because there is less wind resistance but, as Joan Smith demonstrates, if this style of bike catches on it could cause problems for the girls, February 1972.

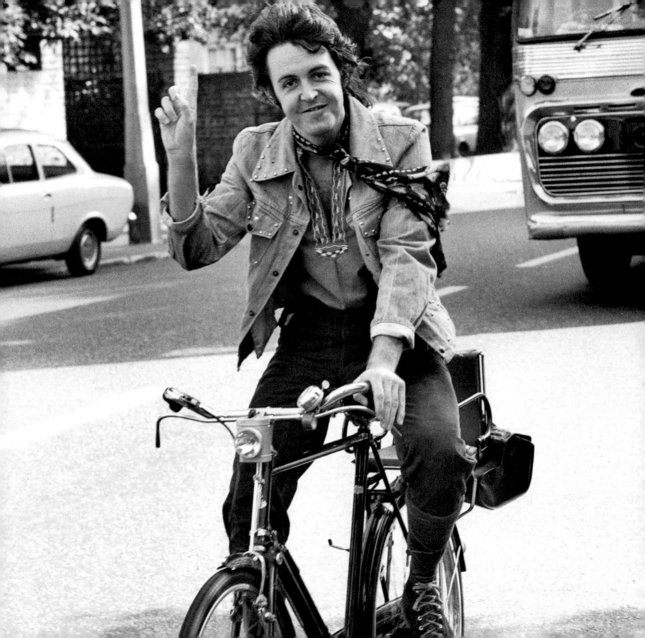

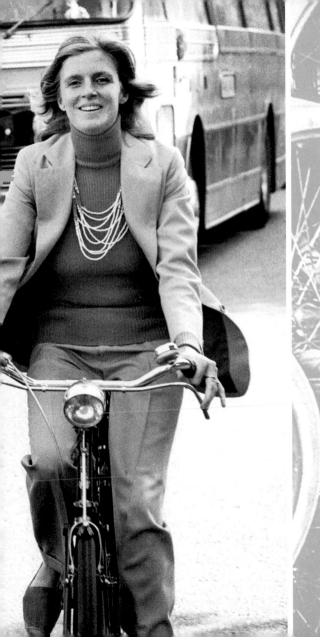

Paul and Linda McCartney out riding
bicycles in February 1973.

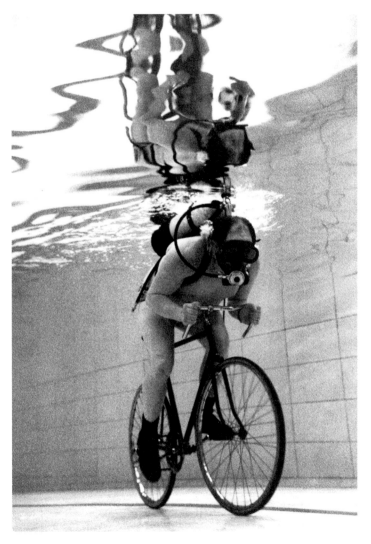

John Camm rides a bicycle underwater at his local swimming pool with the aid of an aqualung compressed air cylinder whilst wearing mask and goggles, January 1973.

The Goodies, on the perfect answer to petrol rationing, ride their three-seater tandem bicycle in London, Wednesday 21 November 1973. The Goodies trio were Tim Brooke-Taylor, Graeme Garden and Bill Oddie.

THE Bicycle

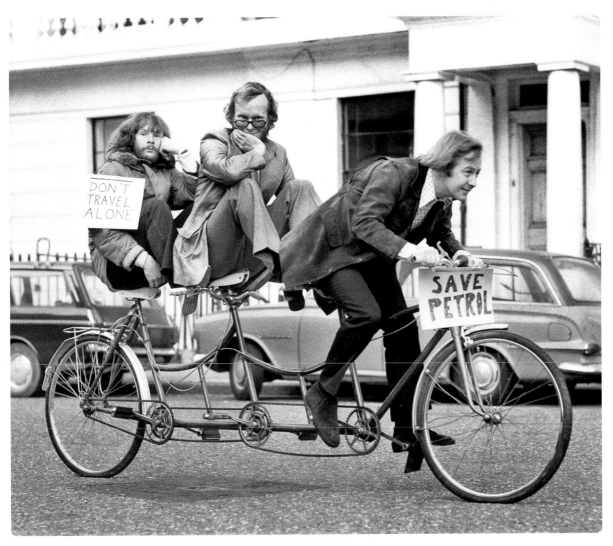

Pam Ayres riding her bicycle near her home in a village in Oxfordshire, 12 May 1977.

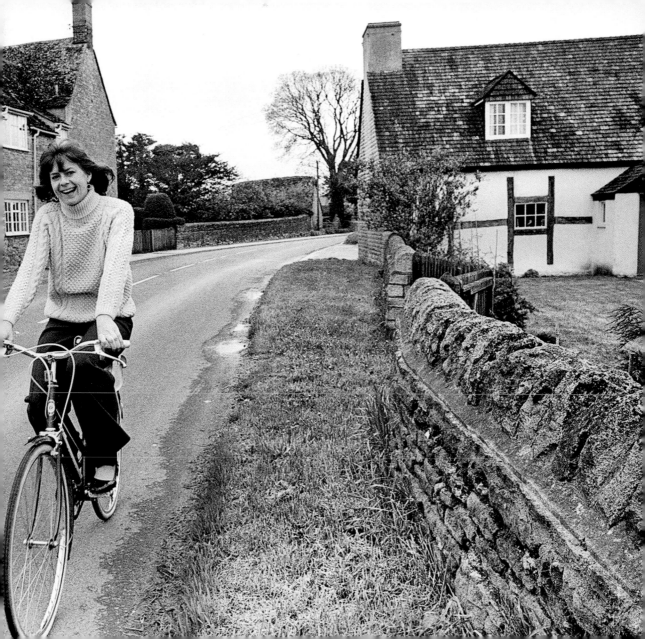

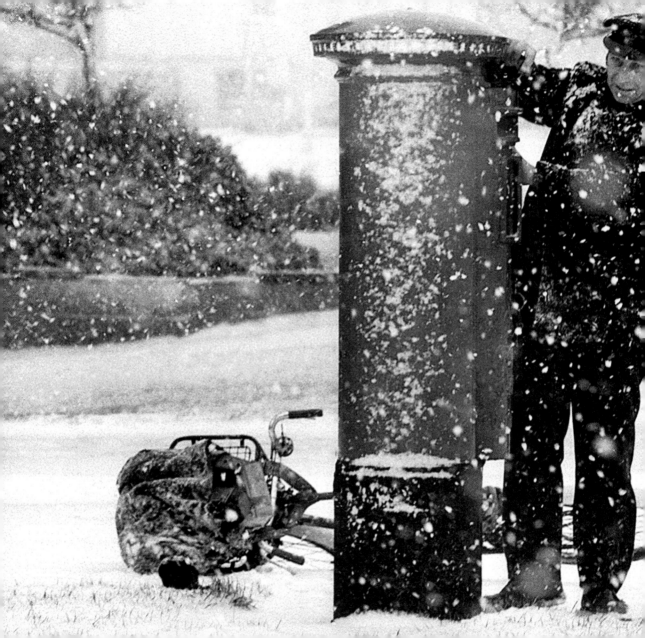

The postman collecting the mail in heavy snow fall at Newington, Ramsgate, Kent, February 1978.

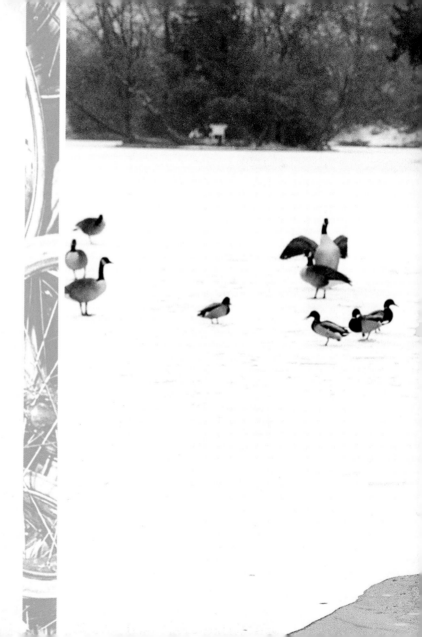

A policeman proceeding around the perimeter of Cannon Hill Park uses his bicycle as a makeshift icebreaker, watched by an audience of mallard and Canada geese, in Birmingham, 12 February 1978.

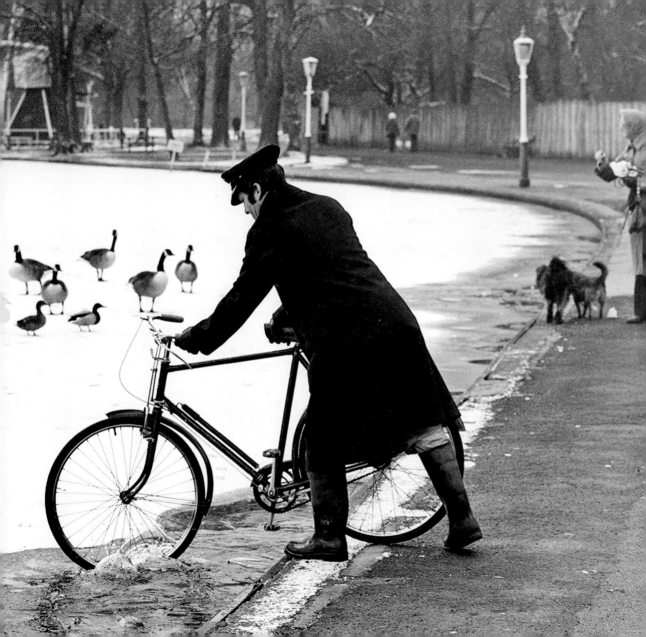

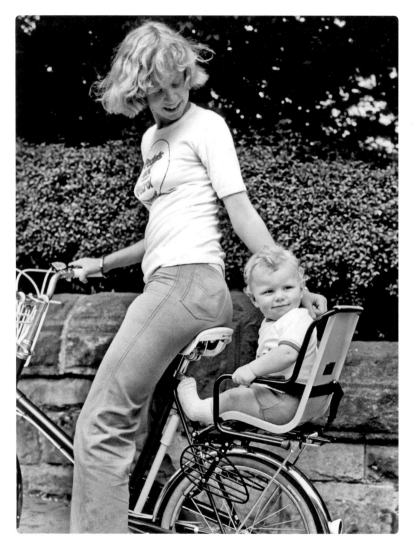

Mother and child cycling,
30 June 1979.

THE Bicycle

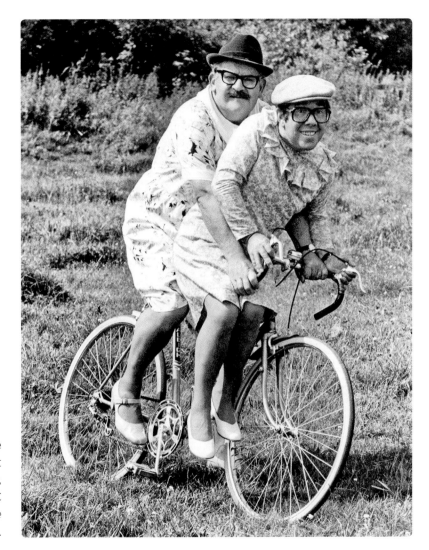

The Two Ronnies: Ronnie Barker and Ronnie Corbett filming at Berkeley, Gloucestershire, for the BBC Television series *Women Rule England*, July 1980.

Charlie Charles pedals the world's smallest rideable bicycle, which is so tiny that the front wheel is made from two silver dollars, April 1983.

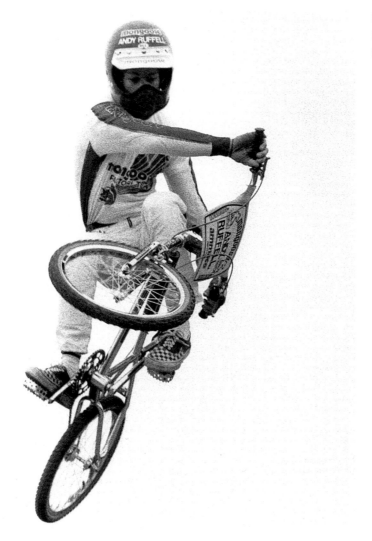

BMX champion Andy Ruffell seen here in mid-air, 15 April 1984.

Children practising stunts at Stockton's redundant racecourse, 20 June 1984. The racecourse is now Teeside Park retail centre.

THE
Bicycle

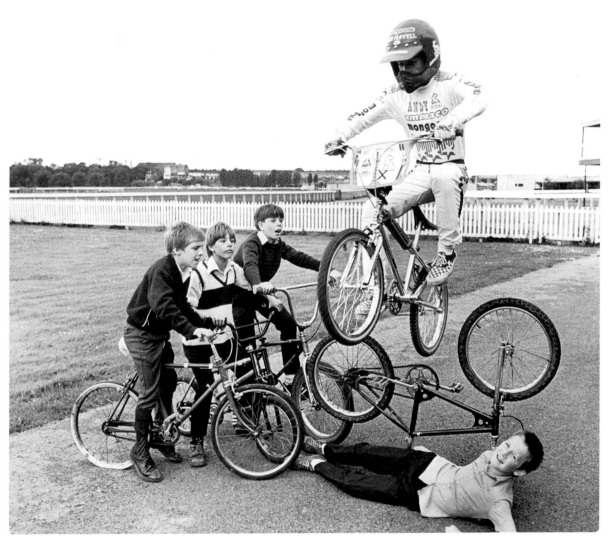

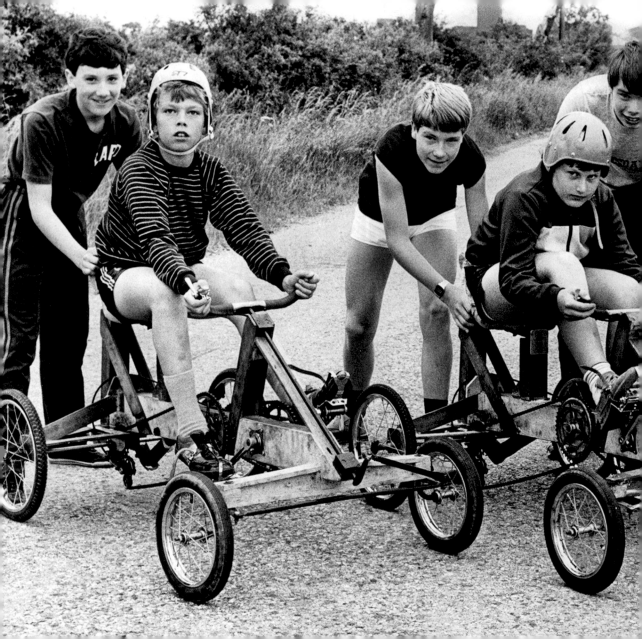

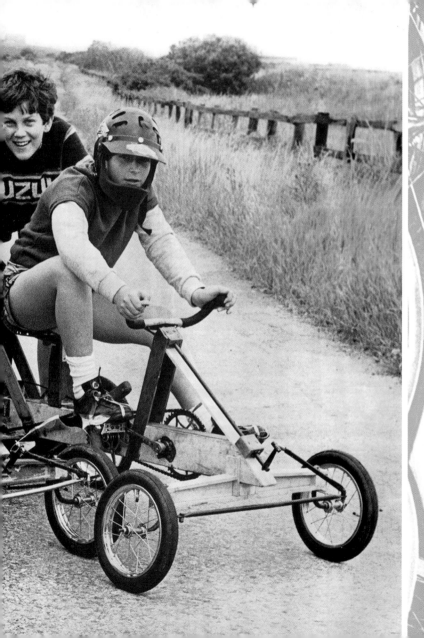

Bits of bike, scrap spare parts, lots of elbow grease and tender loving care have all gone into three very special pedal cars produced in Stockton. Members of the First Fairfield Scouts have all been working hard to get their vehicles, Fairflea, Fairarri and Fairdinkum, in tip-top condition for national races early next month. Pictured with their entries are (left to right) Kenneth Newbrook, Nicholas Weston, Roger Tindale, Martin Rayner, David River, Ivor Mills and Nicholas Lawler, 27 June 1984.

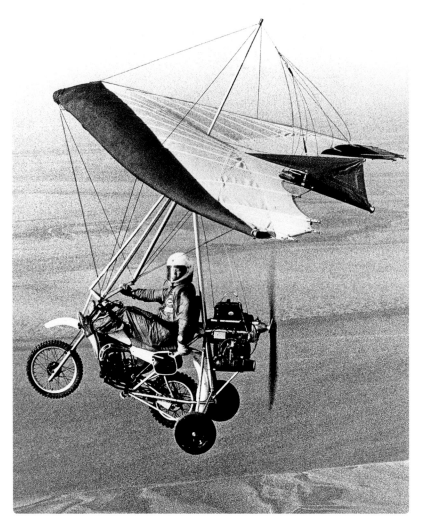

Microlight aircraft motorbike. Test pilot Geoff Ball flies the skybike on its maiden flight over Morecambe Bay in Lancashire.

THE
Bicycle

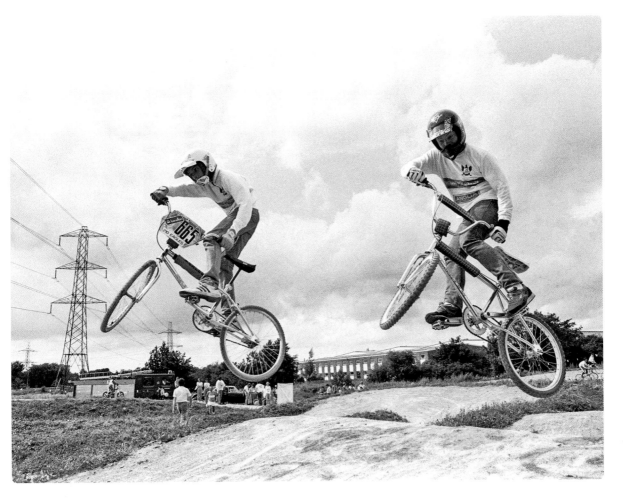

BMX track opens at Waterloo Meadows, Reading, 26 July 1986.

This young man has the wrong transport for getting to school in the floods of 1987.

THE Bicycle

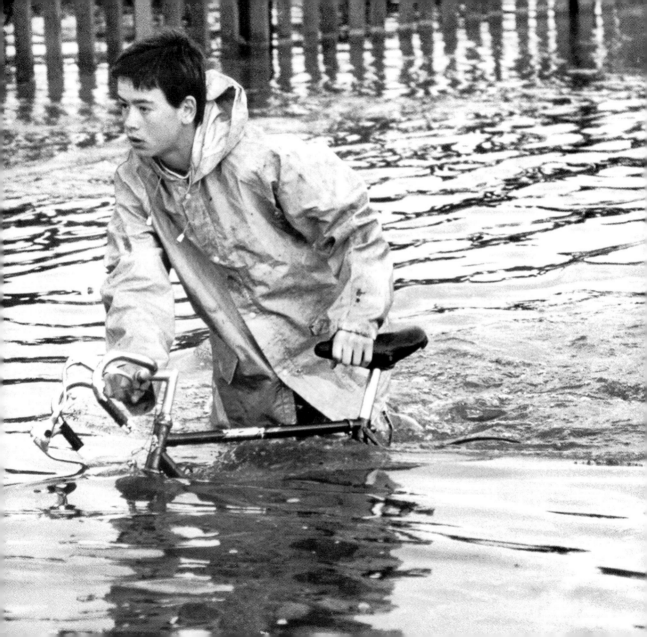

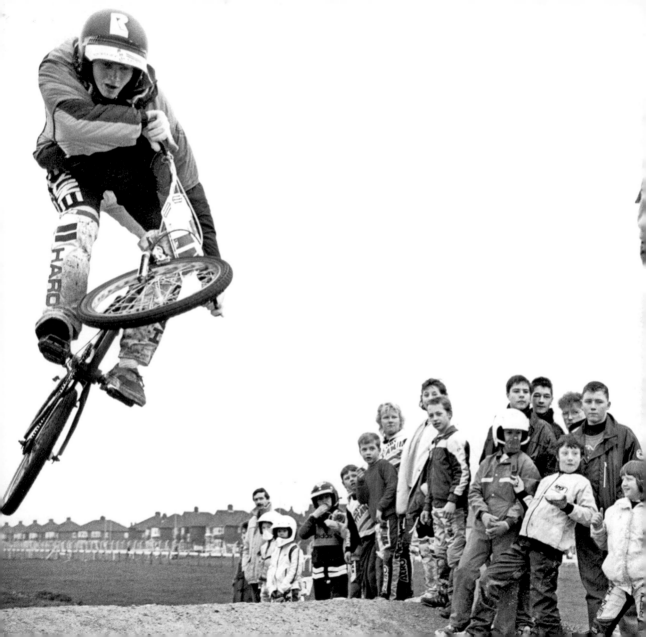

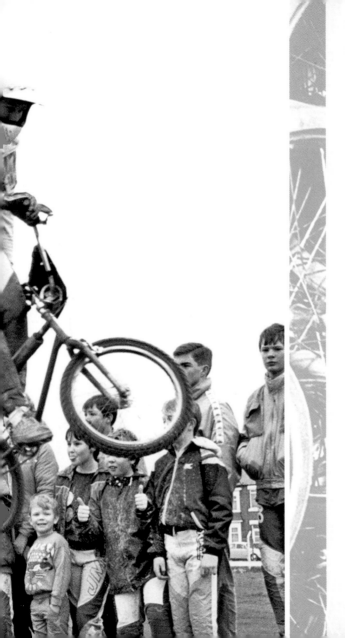

Action from BMX meeting at Cleveland BMX Club, Redcar racecourse, 14 February 1988.

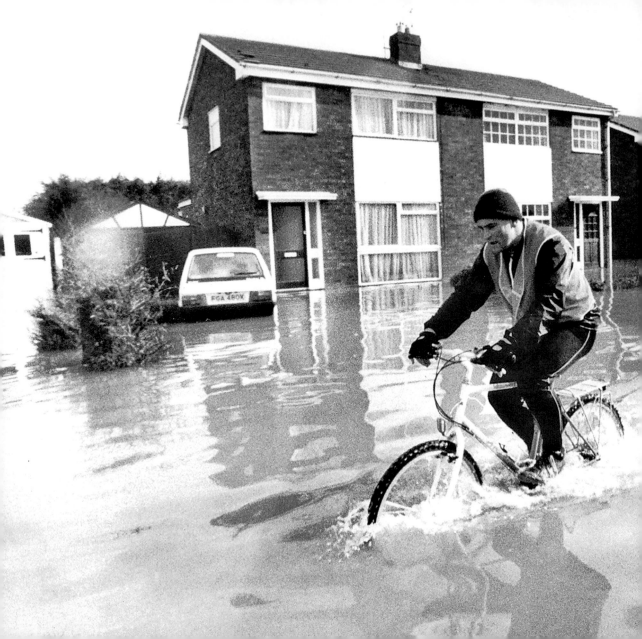

A local resident cycles along a flooded road in the north Wales town of Towyn, March 1990.

Zak Carlin'o performs a high-wire act at the British Steel Gala, Kirkleatham Showground, 7 July 1996.

THE
Bicycle

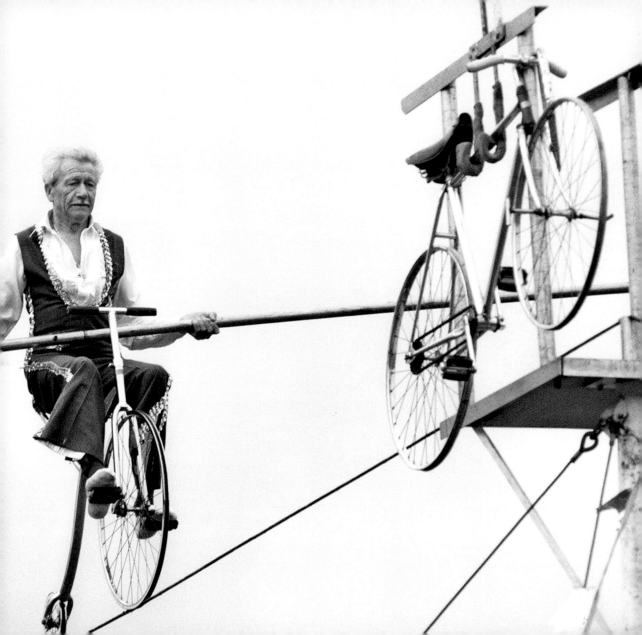

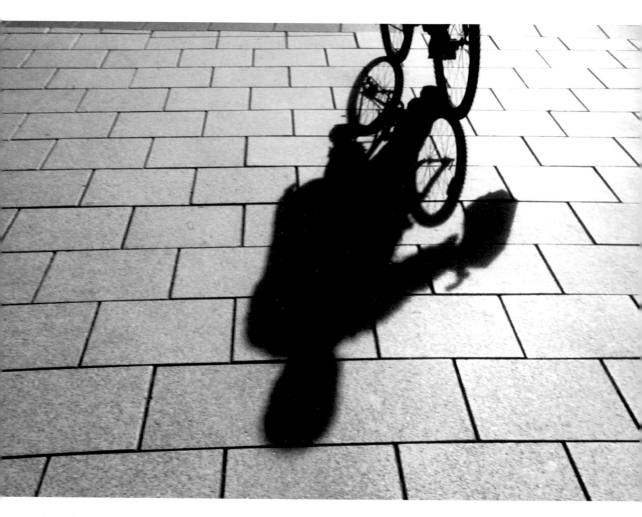

A cyclist casts a shadow across the pavement, 26 August 2005.

THE Bicycle

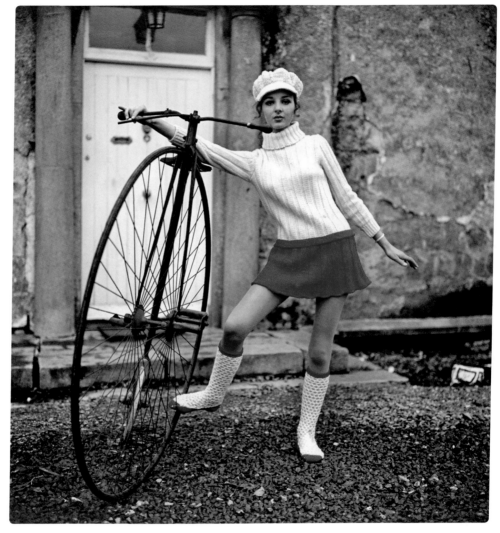

Irish Fashions, November 1969. Anna Andreucetti wears some of designer Cyril Cullen's creations.

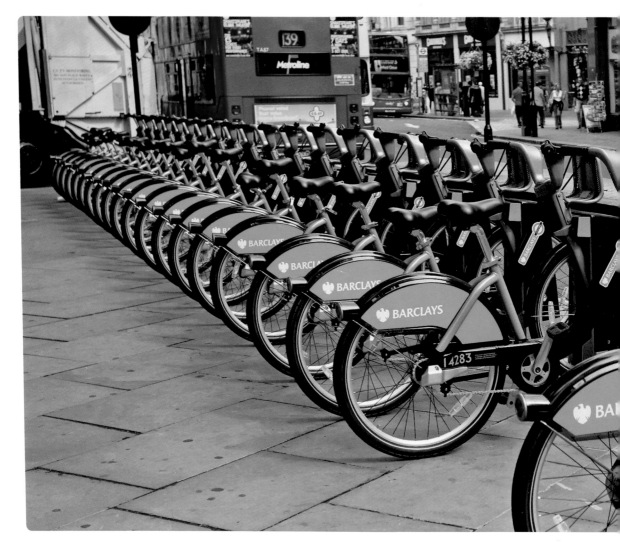

THE
Bicycle

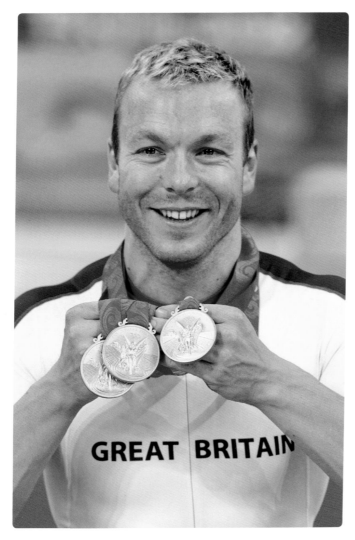

Boris Bikes –
London's cycle-hire
scheme.

Sir Chris Hoy with
three gold medals at
the Beijing Olympics
in 2008.

GREAT BRITAIN

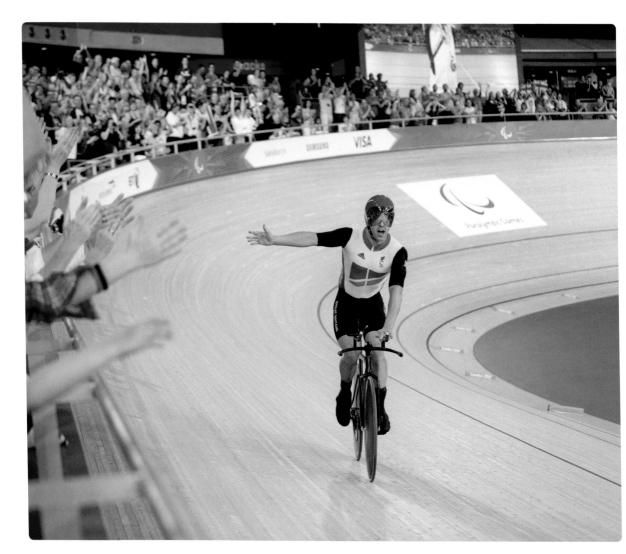

THE Bicycle

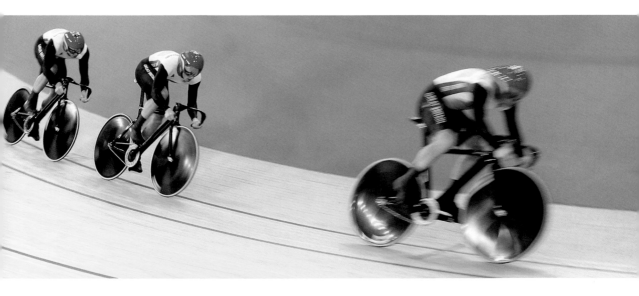

The team cycling event held at the velodrome during the 2012 London Olympic Games.

Team GB Paralympic cyclist Mark
Colbourne wins a gold medal
in the velodrome at the 2012
Paralympic Games.

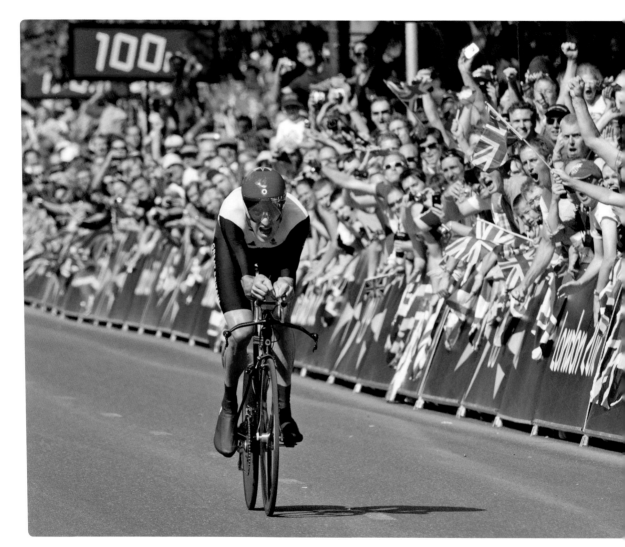

THE
Bicycle

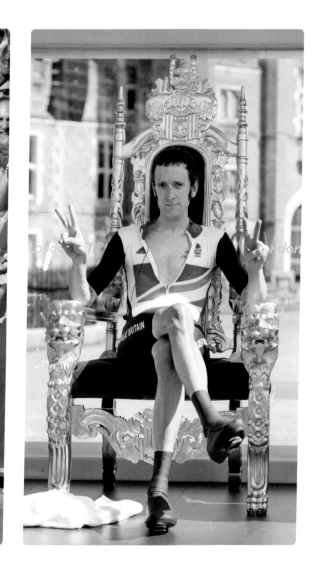

Team GB cyclist Bradley Wiggins pictured during the time trial event at the 2012 London Olympic Games.

Team GB cyclist Bradley Wiggins pictured after winning the time trial event at the London Olympic Games.

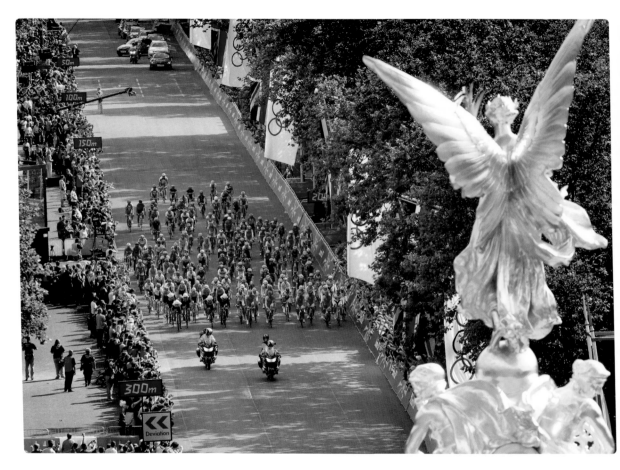

The peloton passes down the Mall as the Olympic competitors head towards Buckingham Palace on the first leg of the men's cycling road race on 28 July 2012.

Sir Chris Hoy of celebrates winning the gold medal in the men's keirin track cycling final on day eleven of the London Olympic Games at the velodrome on 7 August 2012.

THE Bicycle

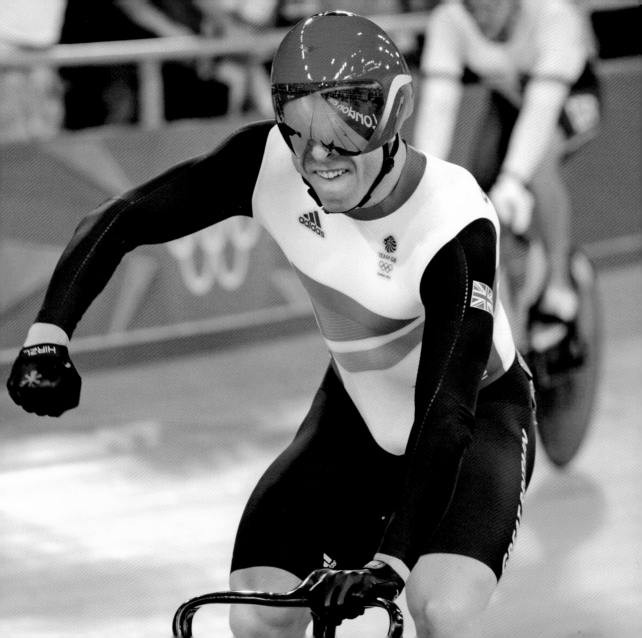

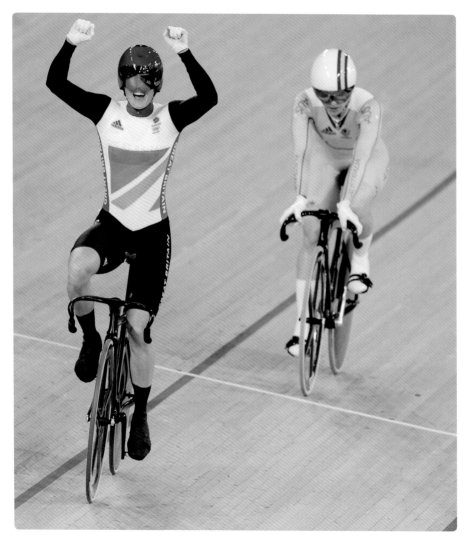

Team GB cyclist Victoria Pendleton celebrates winning gold on the track at the 2012 London Olympic Games.

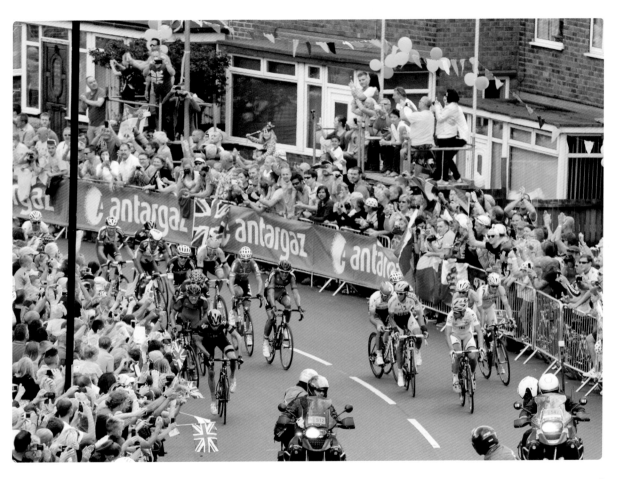

The Tour de France passes through the residential street Jenkin Road in Sheffield, the steepest part of stage two, Sunday 6 July 2014.

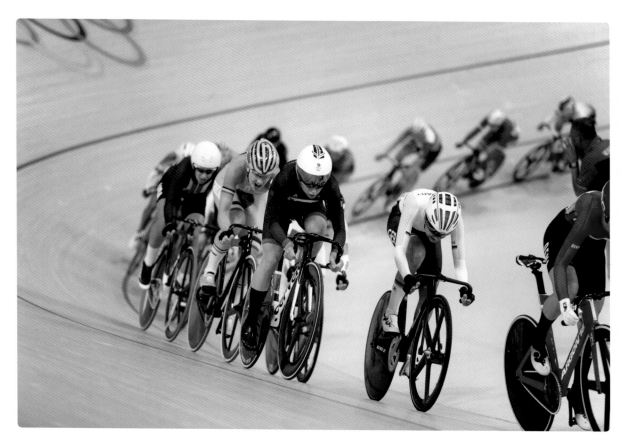

Team GB cyclist Laura Trott wins the gold medal in the women's omnium track race at the 2016 Rio Olympic Games in Rio de Janeiro, Brazil on 16 August 2016.

Team GB cyclist Jason Kenny wins the gold medal as Callum Skinner wins the silver medal in the men's sprint race at the 2016 Rio Olympic Games in Rio de Janeiro, Brazil on 14 August 2016.

THE Bicycle

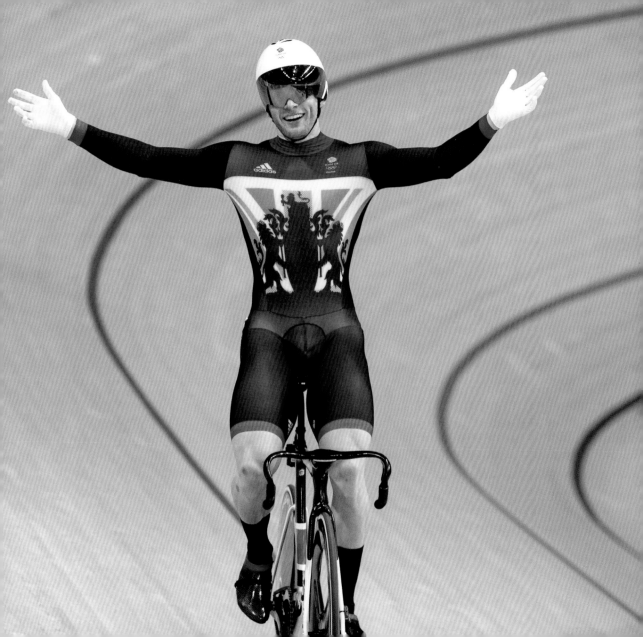

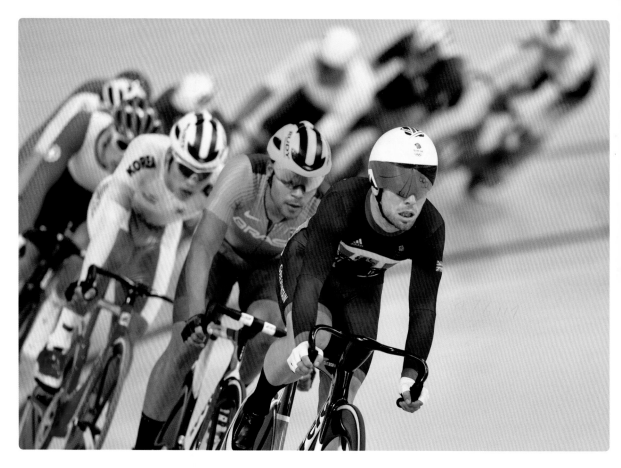

Team GB Track cyclist Mark Cavendish wins the silver medal in the men's omnium track race at the 2016 Rio Olympic Games in Brazil on 15 August 2016.

Chris Froome wins the bronze medal in the road-time trial race at the 2016 Rio Olympic Games on 10 August 2016.

THE Bicycle

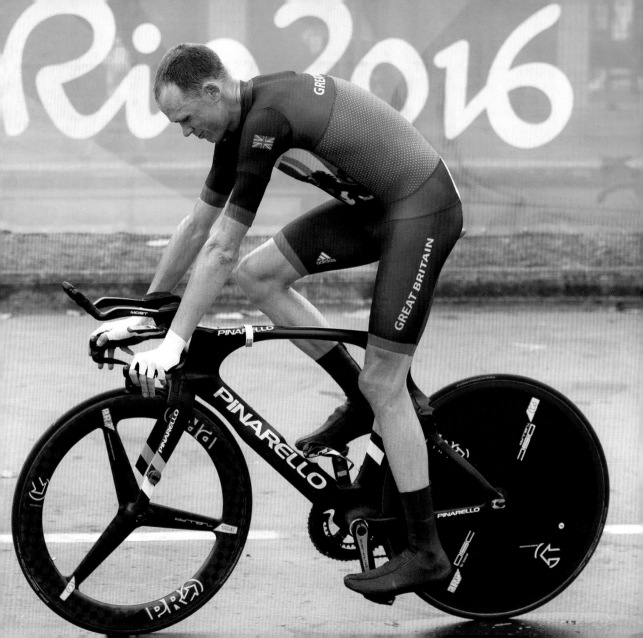

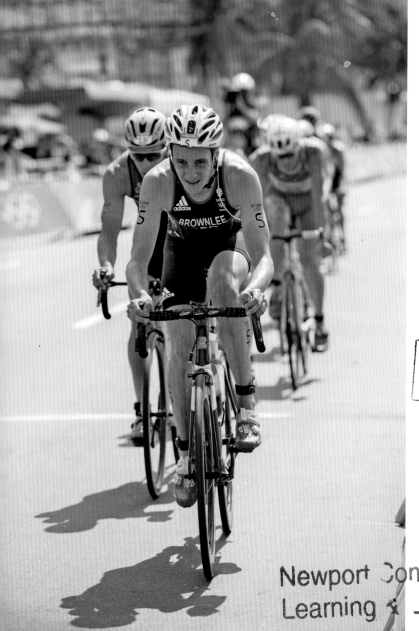

Alistair and Jonathan Brownlee
of Great Britain during the men's
triathlon at Fort Copacabana
on day thirteen of the 2016 Rio
Olympic Games on 18 August 2016.